Art in Britain 1969-70

To M.A., with love from the both of us

Edward Lucie-Smith and Patricia White

Art in Britain 1969-70

J. M. Dent & Sons Limited London

First published 1970

© Text, Edward Lucie-Smith and Patricia White 1970

All Rights Reserved. No part of this publication may be
reproduced, stored in a retrieval system, or transmitted,
in any form or by any means, electronic, mechanical,
photocopying, recording or otherwise, without the
prior permission of J. M. Dent & Sons Limited

printed in Great Britain by
W. S. Cowell Limited
8 Butter Market, Ipswich, Suffolk, England
for J. M. Dent & Sons Limited
Aldine House, Bedford Street, London

ISBN 0 460 03888 5

Acknowledgments

We gratefully acknowledge and offer our sincere thanks
to the following for their help in lending us colour and
half-tone blocks for this book:

Arthur Boyd
Mrs Lilian Browse, Roland, Browse & Delbanco Gallery
J. P. W. Cochrane, Arthur Tooth & Sons Ltd
James Crabtree, Axiom Gallery
Richard Demarco, Richard Demarco Gallery, Edinburgh
Mario Dubsky
Mrs Eric Estorick, Grosvenor Gallery
Brian Ferrans, Arts Council of Northern Ireland
Xavier Fourcade, M. Knoedler & Co. Inc., New York
William Gear
Mark Glazebrook, Whitechapel Art Gallery
Nigel Greenwood
Francis Hawcroft, Whitworth Art Gallery, Manchester
Nils-Gustav Hildeman, Swedish Institute
Mrs Annely Juda, Annely Juda Fine Art
Mr Kasmin, Kasmin Gallery
Mrs Diana Kingsmill, Rowan Gallery
James Kirkman, Marlborough Fine Art
Harry Tatlock Miller, Redfern Gallery
John Morley, Brighton Museum and Art Gallery
Edward Morris, Walker Art Gallery, Liverpool
Anthony d'Offay, d'Offay Couper Gallery
Andrew Patrick, Fine Art Society
Godfrey Pilkington, Piccadilly Gallery
Norman Reid, Tate Gallery
Jeffrey Solomons, New Art Centre
Richard Temple, Temple Gallery
Leslie Waddington, Waddington Galleries
Gabriel White, Arts Council of Great Britain
and we should like to thank the following for their help:
Don Flowerdew, Richard Hamilton, Gordon House.

Contents

Galleries

* Exhibitions organised by Arts Councils

Authors' Foreword

No survey of this kind can hope to cover every
exhibition, or even every exhibition containing
contemporary work, to have been held in Britain
during the year under review. Our aim has been to
select those exhibitions which we believe were the most
interesting and significant, while at the same time giving
a broad and representative sampling of what was
available to the gallery-going public.

Since exhibitions are by no means the whole story so
far as contemporary art is concerned, we refer the
reader to our introductory essay for information of a
more general nature, though much of this material,
of course, is directly related to our comments about
the exhibitions themselves.

Edward Lucie-Smith
Patricia White January, 1970

Introduction

This book has a simple purpose – to make a survey of one year's activities in the field of contemporary art in Britain. These activities can, obviously, be measured and assessed only by the yardstick provided by the works of art themselves, and this is the reason why we have devoted the bulk of our space, and all our illustrations, to exhibitions and art events. But, to be fully understood, these exhibitions and events must be seen against a social, cultural and even a political background, and it is therefore necessary to sketch this out.

For example, it seems plain that the evidence presented here makes it possible to give more accurate answers to a number of the questions which are commonly asked about contemporary British painting and sculpture, about their stature in the world, and about Britain's importance or lack of it as a centre for the visual arts. At the same time, it enables a much more accurate assessment to be made of the success or otherwise of modern art in establishing itself in the regions outside London.

As it turned out, 1969 was both a good year and a bad year to choose for the purposes of the survey. A good year because so many established British artists held one-man shows, and because there were a number of important retrospectives and 'theme' shows (perhaps more of these than ever before). But it was a bad year in which to make an assessment because it was so clearly a period of transition for the institutions which support modern art.

The most important of these were the commercial galleries, at least from the point of view of the amount of art they put on show. Yet it is clear that commercial art galleries are struggling to survive. In 1969, for the first time, one began to feel that their days were numbered. This was not merely due to the economic difficulties which the country suffered during 1969, which were perhaps at least partly responsible for a number of gallery closures, including that of the Robert Fraser Gallery, for long one of the most interesting avant-garde art galleries in London. In particular, the financial crisis compelled the commercial galleries to be less enterprising than they would like to have been in taking on new painters and sculptors. As the boom in auction-room prices showed, works of art have now established themselves as a refuge for capital against the eroding effects of inflation; but only those works of art whose stature is unquestioned – and few living artists are lucky enough to produce painting and sculpture of that kind.

Quite apart from the economic factor, the work which experimental young artists produce seems less and less suitable for exhibition in a commercial context. Many of them glory in the fact. The new Minimal art, created specifically for a given site, or at any rate environmental in its aims, is not the kind of thing which the average commercial galley can exhibit or sell, and still less the kind of thing which the average private collector is able to house. Contemporary art is moving steadily out of the private and into the public sector, and the commercial gallery often seems to hang on as best it can by acting as the middleman between the artist who is in some way subsidised by the state, and the state- or municipally-financed institution which purchases his products.

Plight of the older artist

Where attracting the interest of the audience is concerned, private galleries have for some time been facing increasingly stiff competition from public ones. In the early days of modern art it was the dealers who supported forms of expression which were at that time officially scorned. This hostility has long since vanished: avant-garde artists are as much, or more, the darlings of officialdom as they are of the dealers. Indeed, official or semi-official bodies, such as the Arts Council or the British Council, find more merit in supporting or promoting those who are still in the course of making their reputations than they do in performing the same service for those who have been before the public for some time. This is in many respects a logical and justifiable attitude, but it can create severe problems for artists who reach middle age without having either failed totally, or claimed a place in the first rank. The plight of the older artist who suddenly finds himself ignored by the metropolitan art establishment is a matter for some concern. These older artists are the victims, not so much of conspiracy, as of the inherent inflexibility of the system. Modernism is committed to novelty, and despite the number of exhibitions held each year the amount of exhibition space and exhibition time available is too little to satisfy the needs of all those who have a claim on it.

One of the things which a survey of the year seems to show is a greatly increased amount of exhibition activity in the provinces. There has been, for example, a number of interesting retrospectives in provincial cities devoted to artists who are well known but no longer in the first flight of fashion. Examples include exhibitions of work by Michael Ayrton at Reading, Jack Smith at Hull, Peter Blake at Bristol and William Gear at Belfast and Glasgow.

Limited internationalism

We have called the exhibition pattern in London 'inflexible'. At first sight, this seems a reckless statement. However, if one surveys a year's activity in the leading commercial galleries, at the Tate, at the Hayward Gallery, and at places such as the Institute of Contemporary Arts and the Camden Arts Centre, one begins to see that it has some truth in it. The vaunted internationalism of the London art scene is of a highly specialised kind. Visitors to galleries in the West End see a great range of work by younger British artists: Bridget Riley, John Hoyland, John Walker, Howard Hodgkin, Robyn Denny, Patrick Caulfield and Tess Jaray have all had one-man shows in the twelve months under review. They also see a good range of contemporary American art – the American works in the Pop show at the Hayward, and the totally different structurist reliefs by Charles Biederman at the same gallery; the De Kooning retrospective at the Tate; Jules Olitski and Darby Bannard at the Kasmin Gallery; Morris Louis at Leslie Waddington. Londoners are almost as well informed about contemporary developments in America as New Yorkers are, and many American collectors are said to visit London in order to acquire works by their fellow-countrymen which are difficult to come by at home.

The roster of distinguished Continental artists, especially one-man shows in commercial galleries, is much thinner. Manzù was shown at the Hanover Gallery; there was an exhibition of new work by Karel Appel at Gimpel Fils; the Marlborough New London Gallery staged a show of the work of the Viennese neo-Surrealist Erich Brauer. But younger French, Belgian, Dutch, Italian and German artists, of the kind who achieve regular showings in Paris, are seldom seen in London, which still looks across the Atlantic rather than across the Channel.

This situation is somewhat ameliorated by 'theme' exhibitions, most of them staged in a non-commercial context. Sometimes these theme exhibitions are a straightforward attempt to give Londoners a glimpse of what is being done elsewhere: the show devoted to the work of six young Swedish artists at the Camden Arts Centre, for example. At other times the theme itself is meant to offer a challenge to the audience: this was the case with the Institute of Contemporary Arts show 'When Attitudes Become Form'.

'When Attitudes Become Form' was indeed, as the organisers intended, a milestone, even if a rather gloomy one, in the development of the visual arts in Britain. It was the second major exhibition devoted to the doctrines of Minimal art. The first was entitled 'The Art of the Real', and had appeared at the Tate under the auspices of the Museum of Modern Art, New York, as part of that institution's international programme. 'The Art of the Real' contained the work of American artists only, and it documented the rise of the Minimalist phenomenon by treating it as being in essence purely trans-Atlantic. In this it was perhaps correct. The show at the I.C.A., which had already been seen in a different guise in Amsterdam and Zürich, was also an American-sponsored enterprise, but it did attempt to give those who visited it a better understanding of what had clearly become an international movement. It also gave some idea of the inadequacy of conventional exhibition spaces to do justice to the new ideas which are beginning to mesmerise artists. The I.C.A's gallery is fortunately large, if somewhat gaunt, and it avoids the 'fine art' aura of more pretentious buildings. Many of the exhibits in 'When Attitudes Become Form' nevertheless looked uneasy, simply because this was still clearly an art gallery and the work set out to question the validity of any sort of art-gallery approach on the part of the spectator. In fact, one of the most striking things about the art events of 1969 was the frequency with which artists tried to get away from the gallery concept. There were, for example, an unexpectedly large number of open-air sculpture shows, often dogged by vandalism.

Problems of studio space

One of the most interesting shows of the year was that held at the Stockwell Depot, an old warehouse in South London which has been taken over co-operatively by a group of young artists, most of them working on a large scale, in order to supply themselves with studio space.

The warehouse, though cleaned up a little for the occasion, made no pretence at being a gallery; it was simply the place where the works on view had been created, and very well they looked within it.

Finding studio space is one of the most pressing and most acutely difficult of the problems faced by artists when they leave art school and try to begin their careers in earnest. 1969 saw the first eight months of operation of the S.P.A.C.E. project at St Katharine Docks. The disused St Katharine Docks, now the property of the G.L.C. and awaiting redevelopment, offer magnificent industrial buildings, one of which has also been taken over by an artists' co-operative as studio space at low rents for young artists. Even during its comparatively brief period of operation the scheme has proven both its practicality and its validity. Its success seems to be bringing with it, in addition, a number of interesting re-alignments of attitude.

Role of the Arts Council

Until very recently the avant-garde artists and their supporters in Britain have been able to think in terms of 'us' and 'them'. 'We' included anyone who supported the cause of modern art; 'they' were those who opposed it. This being so, the art department of the Arts Council of Great Britain, the main channel for official patronage of modern art, had a relatively easy time of it. Occasional rows blew up, of course, within the art world; but, on the whole, most of the attacks made upon the Council came from those who were opponents of modern art. Recently this situation has begun to change. Twenty-five years have passed since the end of the war, and those twenty-five years have seen an immense growth in official patronage. But at the same time avant-garde art has diversified its activities to the point where what seems modern to one man seems extremely old hat to another. A young artist in his early twenties, newly graduated from art school, sees nothing very daring in the fact that public money is being spent on Henry Moore, while the structures set up to deal with the kinds of visual art (painting and sculpture) which represented the norm when the Arts Council was founded in 1946 have now begun to seem restrictive and indeed wholly inadequate.

In 1969 the Arts Council tried to meet criticism on the latter score by creating a new committee, the New Activities Committee, to look after such things as mixed media experiments, and equipping it with a small grant. This step has not placated its enemies. The community at St Katharine Docks naturally enough provided a focus for the opposition. A new body, which labelled itself F.A.C.O.P. (Friends of the Arts Council Operative) came into being and summoned a meeting at St Katharine Docks on 8th June 1969. This body accused the Arts Council of the Marcusian sin of 'repressive tolerance' and proceeded to put forward a number of proposals and demands.

A preliminary document (ironically enough this was issued as one number of the magazine *Circuit*, which receives an Arts Council subsidy) put forward the following points. It asked for:

1 A move away from closed secret committees, to a committee structure which would rely for its information, attitudes, values and responsibilities on open meetings involving those most directly concerned, the artists themselves.

2 A move away from the present arbitrary and controversial allocation of resources, to a system of financial recommendation involving a balanced sense of priorities and based on an intimate knowledge of individual, financial, organisational and artistic problems.

3 From the present inadequate attempts to find out 'what's happening' – to communication and information structure which would enable the Arts Council to see and hear what *is* happening.

4 A move away from administration from above, as it were, to a system which gives artists direct responsibility for formulating recommendations for the allocation of material and other resources, to their activities.

5 A move away from a system which merely *responds* to the needs of the artistic community to a system which both responds to and *represents* the art community and its needs.

The proposed meeting duly took place, and a report on its deliberations was issued. This document is not easy to summarise, as those present decided to split up into a number of study groups, and the report includes, in addition, a number of personal statements by some of those who were present. One participant noted the following suggestions as having arisen from the deliberations of the study groups. He classified them as 'positive' and 'negative':

Negative
– Dissociate art from market/profit system.
– Art not to be a form of public relations.
– Dangers of relying on mass-media.
– Disproportion of subsidy to Covent Garden.
– Inability of Arts Council to give advice/support to regions.

Positive

- Industrial production of an idea; to be a co-operative process, to belong to those who take part in the making (e.g. members of factory).
- Use of industrial by-products to enrich environment of working people. Possibilities for play.
- Art as a source of ideas for production processes.
- Co-operative type of organisation (rich subsidise poor).
- Levy on the sale of antique art, to subsidise living arts.
- Split Arts Council: (1) Established ('museum') art; (2) Direct assistance for living arts.
- Link with the restructuring of Arts Schools.

These points – some of the more narrowly particular suggestions have been omitted – seem to us to be a fair summary of the views of many younger British artists. The last suggestion, to do with art schools, acts as a useful reminder of something which is often forgotten: the fact that the exhibition-structure, and especially that part which has to do with the extreme avant-garde, is based on the colleges of art and their teaching.

Art education

It may seem that there were no spectacular developments in the field of art education in 1969, no attempted revolts of the kind that broke out at Guildford and Hornsey (though the Guildford affair, at least, continued to rumble on, with charges and countercharges appearing in the newspapers). But art schools continued to attract praise, criticism and concern, and most young artists in Britain are very much the product of the kind of training they have to offer. Views about them are often in pointed and violent contrast. Mr Gerard de Rose, head of the Faculty of Fine Arts at Maidstone College of Art from 1958 to 1967, was quoted in *The Times* (8th May 1969) as follows:

Fine arts schools should be closed down . . . They're a waste of taxpayers' money. I could write a long thesis on that. They are full of dead-beat people who can't do it, they can only teach. They have to do that to have their telly, their bungalow and their small car. We're just taking money for nothing, aren't we?

Whereas Meryle Secrest, an American visiting the Fine Art Department of the Leeds College of Art, commented thus (*Studio International*, May 1969):

Over the years, a painstaking reassessment has produced an educational experiment at once humanistic, anarchistic and far-reaching in its ramifications, in which the process is more important than the end result.

Miss Secrest offered a shrewd and amusing account of a leading British art college. She noted:

The students can't be mistaken for anyone else. You can spot them coming a mile away, since everybody else in this working-class town looks solid and respectable. . . . There is a light-hearted, antic quality about their behaviour, a kind of innocent spontaneity which seems to suggest that the college is achieving its goal of loosening them up.

She also proffered some more serious and thought-provoking observations about its educational aims:

There is, on the face of it, something outrageous about an art college that doesn't care whether its students ever paint; that cares less about the eternal riddles posed by art than the development of the human potential. But on examination, the concept is not as far-fetched as it might appear.
The days when art could be defined only in terms of sculpture and painting, or even as the unique work of one man's hands, have disappeared . . .
It follows that art schools which continue to think of their goals in terms of producing sculptors and painters are out of touch with the contemporary mood and that what is needed is a school which will encourage the individual to develop his talent in whatever direction seems most inevitable.

Need for patronage

We do not think it too much to assert that art colleges in Britain now provide an alternative system of higher education, with quite different aims from the kind of education which is offered by the universities. It is not merely that the aspirations of those who participate most actively in the art world can for the most part be traced to the education which they received at art college, but that the art schools are beginning to leaven British culture as a whole. The only trouble is that it does not seem to have been the intention of the authorities to set up an alternative system of higher education of this kind, and there is a persistent confusion in the minds of those responsible for the development of colleges of art as to whether the training they offer is purely vocational, or must be thought of in some broader sense.

However lively the art colleges seem, it must be a cause for concern that the students whom they graduate have such difficulty in finding a place in the world. Difficulties of this sort were constantly reported in the press during 1969. For example, Victoria Reilly

reported, in an article in the *Sunday Telegraph* (June 29th 1969):

> . . . it is jobs that are needed and needed fast. More and more people are streaming into art schools. Last year, for instance, 1,664 students were granted their Dip. A.D.; this year it's estimated there will be between 1,800 and 1,900 successful candidates. These students are getting a training and passing exams but will all of them get work?
>
> The sad answer seems to be no; for although as a nation we are becoming increasingly more visually aware and subsidising art training establishments to an even greater degree, we are still not sufficiently prepared to *buy* the inspiration or products of the artists and designers once they have been trained.

Miss Reilly was of course referring to the plight of all students attending art colleges, not merely to those taking fine arts courses. But it is clear that the plight of these latter must be especially acute. May Abbott, in her excellent book, *Careers in Art and Design* (Bodley Head, 1969) remarks frankly: 'To talk of a "career" in Fine Art is really a contradiction in terms, for the study of painting and sculpture is really an end in itself . . . '. But this is a view which fewer and fewer students accept in their hearts or indeed can afford to accept, while the dearth of patronage, and especially of private patronage for modern art, in Britain remains as acute as ever. Many practising artists try to resolve the dilemma by teaching, either part-time or full-time, but good posts are increasingly hard to come by. When the art school system was in a state of rapid expansion – a situation which prevailed until quite recently – gifted young artists found it easy to obtain posts where the work was comparatively light (or failing that comparatively interesting) and the location convenient. This is no longer true, and graduates from art colleges who would like to go into teaching now find the posts they covet occupied by their seniors. This, too, has proved a source of tension within the art world.

At the same time the fact that some colleges are registered for the Diploma in Art and Design (Dip. A.D.) while others are not tends to call the future of those colleges which have not obtained registration into question. One authority with whom we have talked sees these institutions declining into places where 'non-professionals' are taught in their spare time.

These uncertainties account for at least some of the discontent which prevails amongst the very youngest generation of artists. Things do not correspond to the image which their education itself suggests to them. The increasing degree of organisation among young artists, and their sudden militancy, are a reaction to this. The St Katharine Docks scheme is of course a striking example, and it is notable, here, that the community which has come into being at the Docks is, in its atmosphere, very like a progressive college of art. Superbly equipped and imaginatively administered, the best art colleges offer the young artist an environment which is on the whole more favourable to creative activity than any which he is likely to discover again. Usually he has a grant; usually he is not as yet burdened with family responsibilities. Studio space is available to him free, and so is the latest equipment. He can interest himself in a whole range of activities: painting, sculpture, graphics, photography, film, and find the equipment he needs ready to hand. The one thing he will not always find is emphatic guidance as to what he should do with these facilities, and opinions differ as to whether this lack of guidance is a good thing or a bad. The catalogue of the Royal College of Art Painting School Graduate Show of 1969 actually boasted in a preface that 'diversity is maintained throughout by non-emphatic tutoring'.

The Artist Placement Group
The militancy of the artists in conducting their affairs was in 1969 matched by a sense of uncertainty about the purpose of art itself. When the militants attacked the Arts Council for its policies, it was difficult to discover if precisely what they had in mind was something positive and desirable. Yet slowly an effort appeared to be getting under way to redefine the artist and his activities. One example of this was the work of the Artist Placement Group, a body which has been in existence since 1965. In essence, what this group wishes to do is to 'persuade industrialists to take into their organisations, and pay them as licensed opposition to currency dictatorship (dollar accountancy) – artists'. (*APG News*, Number 1, May 1969). In 1969 the Artist Placement Group achieved their first substantial success in placing artists within industrial concerns. Among the first to be taken on in this way was the young sculptor Garth Evans, who was given a fellowship for a year by the British Steel Corporation. The terms of his engagement were that he should familiarise himself with steel and its possibilities, and would be free to work with the material as seemed best to him.

What the Artist Placement Group was doing was trying to regularise and define a situation which already existed. In Britain as elsewhere, artists were beginning to turn towards industry. Instead of thinking of the artist as a man isolated from the community, pursuing in solitude a wholly different kind of activity, they began to resent the isolation of the fine arts and to try to do something to break down the barriers.

New techniques for the sculptor

The switch in emphasis from painting to sculpture was part of the change, and at the same time helped to accelerate it. It is true that painters have begun to make extensive use of new materials – acrylic paints, in particular – and of new techniques, such as the silkscreening of photographic images. But painting still remains what it has always been: the application of pigment to a support. In new materials, sculpture found a much greater range of possibilities. From the direct welding of steel, artists moved towards the use of plastics. Often, the kind of concept which they now had in mind required industrial collaboration if it was to be successfully realised. The artist would plan his forms, and make a mock-up, but the finished work would not be made by his own hands, simply to his own specification. Sculptors using bronze in the traditional way were already accustomed to the idea of sending their work away to be cast. Direct welding techniques no sooner broke this dependence on the outside craftsman than an interest in plastics restored it. But the atmosphere of a small industrial firm dealing in plastics is a very different thing from that of a bronze-caster's workshop. Traditional notions are paramount in one, the other has scarcely had time to develop traditions.

The artist's choice of plastic as his material will be dictated by a number of factors, not least among them the one we commonly label 'sensibility'. The artist who works in plastics is already identifying himself with the civilisation in which such materials are commonplace; by his choice he acknowledges his connection with the technology which produces what he is shaping.

From this tentative beginning has gradually grown the desire on the part of the artist to achieve a sensible working relationship with industrial techniques. By finding out what these are, and what they will do for him, he at the same time enlarges his vocabulary of forms. But the gap between the individual, working

according to the dictates of his own vision, and in his own time, and the complex schedules of a large industrial organisation is by no means an easy one to bridge. The Artist Placement Group is in the course of organising an exhibition to be shown at the Hayward Gallery in the summer of 1970, and this will no doubt serve as a progress report on how far it has been possible to bring art and industry together.

The decline of the commercial galleries and the new attitude among artists have been joined by another important factor which directly affects the way in which the contemporary visual arts reach the public, and the way in which the public reacts to them. This is decentralisation. The decentralisation of the arts has been official government policy since the White Paper on *A Policy for the Arts: the first steps* was published in 1965. This book records a much greater number of exhibitions outside London than would have been the case had the volume been published even three or four years ago, and these exhibitions are often of an adventurous kind. And this is only the tip of the iceberg. Anyone who travels extensively in the provinces soon becomes aware that art activities in general are much livelier than they used to be. The driving force is often provided by men who work at the local college of art. In fact, the most available members of the avant-garde in any city outside London will usually be those whose primary interest lies in the visual arts. The musical and literary avant-garde remain far more dependent on the metropolis.

Creation of Arts Centres

One particularly significant tendency has been towards the creation of arts centres. The Department of Education and Science, with whom the responsibility for government help to the arts ultimately rests, has been actively encouraging the creation of these ever since the White Paper was published. Recently the Department published (Administrative Memorandum No. 9/69 – 15th July 1969) the report of a Working Party on Arts Facilities. This report is interesting on many counts – not least because of the emphasis which it puts on non-vocational participation in the arts, and on the arts as an educational activity. Where arts centres were concerned, the working party had this to say:

While arts centres may vary enormously in size from a single hall to an elaborate complex of buildings, they

occupy a unique position among the institutions under consideration in that the provision of general arts facilities is their primary, not secondary, function. The essential features of an arts centre are that it should be concerned with more than one of the arts, that it should be a place where people can meet informally, e.g. to exchange ideas over a cup of coffee, and that it should act as a focal point for cultural activities in its community.

This, significantly enough, is not unlike the kind of programme put forward by the most vocal critics of the Arts Council. The 'new activities' which they advocate are essentially mixed media activities, a coming together of all the arts. But matters remain ambiguous. The Institute of Contemporary Arts, despite the favourable publicity which it has on the whole attracted, is reported to be having difficulty in finding the finance for its ambitious programme, which covers most spheres of artistic activity. The Arts Laboratory in Drury Lane collapsed altogether in the autumn of 1969, though an offshoot with a similar programme survived.

The artist and social change

If we are to make some attempt to define the problems which confronted artists in Britain during 1969, we must say that, on the evidence, the chief problem is one of professional status. We are aware that this problem is generally held to have been solved in the nineteenth century, when painters and sculptors, like actors, established their status as professional men, on a level with doctors, parsons and lawyers. But this position, so painfully built up, has now been undermined again both by the development of modernism and by social change.

The reasons are complex. Some are universal, and apply to countries other than Britain. In fact, they are to be found in operation wherever modernism has become the dominant mode. Chief among them is the emphasis which is placed on the individual, on the artist's right to conduct himself as he pleases, and, in particular, to create as he pleases, without regard to social pressures. So many historical forces combine to make the modern artist a professional 'outsider' that he finds difficulty in playing any kind of role in a group situation – most of all in those where the group is not confined to artists. Yet group situations more and more tend to be forced upon him.

Curiously enough, while the commercial gallery flourished it tended to protect the artist and to liberate him to follow the dictates of his own fantasy. As such galleries decline, the artist is once again forced to negotiate on his own behalf. The manifestos issued by artists, when they set themselves up in opposition to the sources of official patronage, such as the Arts Council, often have a comically bombastic tone, as if the signatories were asking to be treated not merely as adults, who ought in justice to be allowed to have some say in their own future, but as a different and superior race of beings.

Patronage

At the same time there is an increasing tendency for the artist to find the financial support cut from under him, not only by changing economic conditions but by changes within the pattern of society, and indeed by aesthetic shifts as well. All of these tend to break down the commercial structure which has hitherto supported the artist. In the short term, commercial galleries find it difficult to sell modern art, especially in its more extreme forms, because the economic situation means a shortage of ready cash. At the same time the pattern of patronage seems to be changing permanently. There has always been a shortage of private patrons for modern art in Britain: we are a nation in which modernism was slow to take root. Now, when it is becoming accepted, taxation still stunts the growth of patronage on the American pattern. There does exist a large minority interested in modern painting and sculpture, and who might even like to have examples in their homes, as well as going to look at it in exhibitions. But few of them can afford the price of an 'original', and many of them do not have the space to house such an original even if they could afford it. The result is that they tend to buy things which are both cheaper and less bulky – which means, for the most part, prints and the newly-fashionable multiples.

Though print-making is certainly an activity which has increased enormously in recent years, the return from graphics and multiples is seldom enough to give even a well-known artist enough to live on. Instead he must turn, as we have already pointed out, to the state for support.

In Britain the state does indeed play a constant and increasing role; a large part of the financing of the visual arts now devolves upon it. In some ways this is more remarkable than is usually acknowledged. There seems to us no question, for example, that modern

painting and sculpture remain a minority taste, though the minority is one which is constantly increasing in size. The state thus extends its encouragement to art which a substantial proportion of the electorate either actively dislikes or is unaware of. The fact that modern artists have been so far unable to shake off their élitist attitudes seriously weakens their claim when they enter into negotiations with their principal patron – though this is something they have been slow to realise.

The artist is drawn by his own principles and inclinations in two entirely different directions (the dilemma, of course, is almost as old as modernism itself). On the one hand he wants to express his own individuality, and the superiority of the creative process – its ability to vanquish whatever is opposed to it. At the same time the artist wants to participate in the activities of the society which surrounds him, and to communicate to that society. The tension must necessarily make him feel uncertain of his real status.

The artist and teaching

But there are other ambiguities, which are more particularly related to the British national situation. For example, the *visible* patronage of the visual arts on the part of the state and of local authorities – purchases of pictures, prizes and bursaries, exhibition costs – is matched, and overmatched, by subsidies which are less visible. The chief part of these comes from the art school system. Most artists teach; indeed, few of them could live without teaching. Many argue that the income thus gained is not the rate for the job as a teacher, but the rate for the job as an artist. Similarly, students on grants clearly think of themselves as being paid while they learn to become artists; the Dip. A.D. or other professional qualification which they are supposedly working towards while living on their grants is a matter of secondary interest.

These are assumptions which have grown up over a period of years, but they are assumptions and nothing more. As a formal structure, the college of art promises nothing of the kind. Its fine arts courses for the most part seem designed to give students the basic equipment to be teachers of art, not artists *tout court*.

Artists in Britain are therefore on slippery ground professionally, a fact which emerges when (as began to happen in the year under review) they begin to band themselves together so as to conduct joint negotiations with bodies which may, without too much absurdity, be designated as their employers. The Arts Council increasingly stands in much the same position *vis-à-vis* the working artist as the National Coal Board does *vis-à-vis* the miner. The difference is that the artist cannot very well threaten to withdraw his labour, because people know less and less how his task is to be defined, or what the 'product' is. Ever since the Constructivists allied themselves to the Bolshevik Revolution, attempts have been made to redefine modern art as work in the Marxist sense. The issue still remains unclear.

Matters are indeed becoming increasingly obscure, for a reason which has scarcely been touched on as yet – the fact that professionalism in the old sense of the term is exactly what modern art is trying to discard. In *Art and Artists* (April 1969) David F. Sweet commented:

The glossing over of the difficulties and pitfalls of making competent art works, the belief that art equals creativity and creativity is something everyone can develop, fits in with the current reluctance to inculcate into students any concept of an external hierarchical structure of judgment, any value system.

Value judgments are not the only things which are suspect; so is instruction which touches upon the question of technique. The student is not told that *this* is the way to do it, because such teaching might inhibit the search for himself which is the most important part of his education. Meryle Secrest reports about the course in Leeds that 'there are occasional nervous breakdowns, the result of the tremendous pressures some individuals feel when forced to discover who they are'.

Amateur activity

The command of technique is, however, one of the traditional marks of the professional, as opposed to the amateur, in all the arts. If the artist is merely to be someone who has discovered who he is, then the part-timer may well make a claim to a bigger share in the action. And this is what seems to be happening. When the Working Party on Arts Facilities, part of whose report has already been quoted, asserts that 'The backbone of most arts centres is amateur activity', they are enunciating a more significant truth than may appear on the surface. If people are becoming increasingly concerned with the visual arts (and we believe that they are), this concern takes an interesting form – it is bound up with the desire to create, to make something for oneself. The increase in leisure is prompting many

people not merely to appreciate the visual arts in a passive or spectatorial way, but to participate actively. How is the full-time artist to draw the line between these people and himself? And is he entitled to do so? They too are in search of that part or aspect of themselves which he seeks to discover. Even the adjective 'full-time' is probably a misnomer because, as we have seen, most artists are forced to teach for at least one or two days a week in order to make ends meet.

The professional status of the artist is thus threatened by the democratisation of the arts which for many reasons he cannot oppose. First, the whole process fits in with his own philosophy. Secondly, if he tries to find some grounds for opposing state aid to amateurs, on the same terms as it is granted to himself or those whom he accepts as fellow professionals, he immediately lands himself in a thicket of contradictions. Thirdly, no government would countenance such a refusal, for reasons which scarcely need to be spelt out.

There is one further reason why the artist who lays claim to be a professional finds himself devalued in the eyes of society and, in particular, in the eyes of those with whom he has to negotiate in order to ensure himself a livelihood. David F. Sweet puts the point succinctly in the article already quoted:

One of the most suspicious features of the present educational set-up is the sheer number of students involved. In fine art departments up and down the country there must be thousands of young people engaged in an activity generally regarded as the special province of uncommon individuals. For many reasons, mostly bound up with the changes brought about by twentieth-century developments, the exclusive nature of art making has been eroded, and with the crumbling of esoteric privileges it has been brought within the range of anyone with the slightest aptitude.

In effect, the artist no longer commands the respect he feels is due to him because artists are simply too numerous.

Purpose of art training

We have already examined the contradictions which exist within the art school system – the fact, for example, that those who teach and are taught think of the art school as existing for one purpose (self discovery) while those who regulate and those who administer the system from outside think of it as being for quite another (the preparation of students for an examination which in turn leads to some kind of professional qualification).

It is worth re-emphasising the fact that, whichever of these views prevails, society still finds difficulty in absorbing and using the apparently qualified graduate. If art schools were accepted as institutions which offered an alternative form of general education to that which can be got at a university, these difficulties might disappear. But this would involve a total and radical rethinking of what the artist is, and how he should operate in a modern society.

So far, there are few signs that such a reconsideration is taking place. The prevalent hostility to 'students' in Britain is, in part at least, a hostility to the life style which the art schools have pioneered and which has produced an anti-libertarian backlash strikingly reminiscent of the racialist backlash.

Stagnation

As the number of exhibitions by British artists in the year under review serves to remind us, one way of judging the system of art education is by the quality of the artists which it produces. In recent years British art has been much trumpeted, and younger British artists have a number of major awards to their credit – the most recent being the major prize for painting at the Venice Biennale, which in 1968 went to Bridget Riley, while Anthony Caro also won an important prize at the São Paulo Biennale. But in our view the situation is less healthy than is generally supposed.

We have noted that most of the leading British painters and sculptors held exhibitions of their work in 1969. It is illuminating how closely these artists can be grouped together. Of the British modernists of the 'ruling generation', Richard Hamilton is about the oldest, David Hockney very nearly the youngest. Though some of the shows were of striking quality (Hamilton's in particular), few showed any marked break or change of style. In contrast to the exciting days of the early fifties, this is predictable modernism, which has established both its own limits and its own formal vocabulary. This impression was conveyed with especial force by various exhibitions of sculpture by highly-praised young artists. The contemptuous American phrase about 'the school of British lightweights' came all too frequently to mind.

This establishment is still young, however, and there are few challengers to it. Big prizes, for instance, still regularly go to the known names – for example, the award of the John Moores prize of 1969 jointly to

Richard Hamilton and the late Mary Martin. Attempts to survey the work of younger and less-established artists tend to come up with contradictory conclusions – for example, the interesting 'Young and Fantastic' exhibition arranged by Mario Amaya for Macy's department store in New York, and briefly shown at the I.C.A. before its departure across the Atlantic. Amaya picked on a neo-surrealist strain as something new in British art, or at least as something which had not made itself felt so strongly before. But the exhibits he picked to support his thesis were too various to suggest that anything like a new movement had begun.

Many critics would say that the hunger for a new movement, for total and radical changes of style at frequent intervals, is one of the weaknesses of the British art world, just as it is the weakness of the art world in New York. In this they may well be right – we certainly have the suspicion that art in Britain is too often a fashionable commodity, that this season's picture exists just as much as this season's dress, and remains valid for as brief a period. On the other hand, it was dismaying to see the stagnation which prevailed in the diploma shows of the leading London colleges of art.

One explanation for this is that painting and sculpture are now outmoded forms of expression, or at least are rapidly becoming so, and that the mixed media must necessarily triumph. 1969 certainly saw more environmental exhibitions than ever before. It sometimes seemed that no festival of the arts was complete without one. But the feebleness, from the aesthetic point of view, of most of the offerings at these exhibitions was also striking. While some part of this lack of effect might be attributed to unsuitable settings, some of it was certainly the fault of the artists themselves. There was no sign that the new modes of expression would generate the same excitement as did, for example, the arrival of Pop.

Another disturbing feature of much of this extreme avant-garde activity was its derivativeness. Britain could make no claim to be in the Minimalist vanguard. In fact, the British art world appeared less, rather than more, international in 1969, and one had the feeling (absent for some years) that this was a country where foreign influences arrived both slowly and rather intermittently.

We have spoken of the lack of exhibitions by leading Continental painters, which was perhaps a consequence of the difficulty of finding patrons in Britain. Leading Americans seemed to be shown more for the benefit of American visitors than for the resident British. If one considers the great quantity of American painting which has been shown in London over the past few years, that part of it which has actually found a permanent home in Britain is astonishingly small. The *range* of work by Americans which is exhibited here is often narrow, despite the frequency of exhibitions. London is essentially a province of the Greenbergians at the moment, and Clement Greenberg himself is probably more influential than any British critic in determining the pattern of what is shown here. This, again, reflects the dearth of British patronage, and the importance of American clients to British dealers.

The future for modern art
Given that the situation is, in broad outline, as we have described it, what is the future for modern art in Britain? Clearly, if the economic situation improves, prospects for artists will also improve. Equally clearly, the importance of the commercial galleries will continue to decline, though it is doubtful whether these galleries will ever disappear altogether. In fact, minor galleries continue to open and close with such rapidity that the critic is hard put to keep up with them. One lack which is already making itself felt is that of small galleries with a fixed policy, dedicated to promoting a particular aesthetic philosophy. Since Signals and the Indica Gallery closed, Londoners have seen much less kinetic art, though on the international scene it remains as important as ever. The closure of the Robert Fraser Gallery affects the prospects of painters with Pop affiliations, as this was one of the great strongholds of Pop art. One of the weaknesses of the publicly-run art gallery is that it cannot champion a cause in this way, even under the direction of an enthusiastic and dedicated individual.

The didactic show, which illustrates a theory or makes a point, falls naturally within the public sector and, from the point of view of exhibition organisers, it has a number of very practical advantages. The supply of artists who can sustain a retrospective on a large scale is running out, and prohibitive insurance costs and the reluctance of owners to part for a while with their possessions make it more and more difficult to mount a large exhibition dedicated to one of the great names of modern art.

On the other hand, the retrospective devoted to the work of an interesting but not entirely established artist

is, from the organisers' point of view, a considerable gamble. The Mark Boyle show at the I.C.A. drew very disappointing attendances despite the fact that Boyle is one of the most talked-about younger British artists.

The rise of the theme show has tended to increase the importance of the impresario at the expense of that of the artist. It is the impresario who chooses the context within which the work will be exhibited, and it is he who chooses the thesis to be argued. The work of art becomes simply one of the bricks from which the show is built. Here is yet another threat to the artist's status.

In fact, despite the immense superstructure which modern art has now built for itself in Britain – galleries, exhibitions, grants, committees – the declining status of the artist is the single fact which emerges most forcibly from the researches we have made for this book. It seems to us that artists are still only dimly aware of what is happening. The rumblings of discontent recorded here are still only rumblings; there is only the beginnings of cohesion among artists to resist what is happening, and the resistance is not always sensibly conducted. The one thing which would probably change this would be a serious threat to the art school system as it now exists. The inconsistencies of the system are now so numerous that it seems inevitable that changes will be made. Can rationalisation be anything but unfavourable to the practising artist?

At the moment, artists benefit from this system in the manner we have described, but these benefits are the concessions made by custom. The kind of education offered at a progressive art school, and the kind of subsidy for the practising artist which a job in such an art school provides, are things which have established themselves, not thanks to any kind of regulation, but almost insensibly and in the course of time. Any disturbance of the *status quo* would, we believe, be the cause of considerable hardship.

But this begs the larger question, which is this: what is the place of the arts in the kind of society which we now have in Britain? As can be seen from the text and illustrations of this volume an immense amount of activity takes place, and although the quality of that activity may sometimes be questionable, it still overwhelms by its sheer quantity. What its *relevance* is remains in doubt. More painting-classes for housewives or more statues on new housing estates are self-evidently no kind of a solution. Nor is the creation of a new élite, the prophets of self-knowledge, the *gurus*

and *chelas* of the cult of art. In banding themselves together to defend their rights, artists often seem to be in danger of asserting that they belong to a special group for which the community is responsible, but which in turn owes no responsibility except to its own members. The problem is not merely British, but exists in all the Western democracies. It is particularly keenly felt in Britain because of the close-knit quality of British society as a whole.

While we wish to raise this question, because we think it important, we should also like to emphasise the fact that it is not our main purpose to offer solutions, but to show the full range of activity in a given year. The evidence is so copious that other conclusions might well be drawn from it, and it is the evidence which counts.

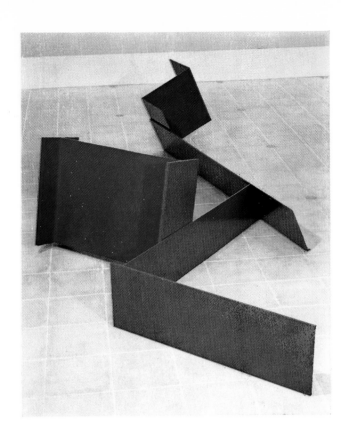

Anthony Caro Shaftesbury 1965
Steel painted purple 2′ 3″ × 10′ 7″ × 9′
Private collection, Boston
Hayward Gallery

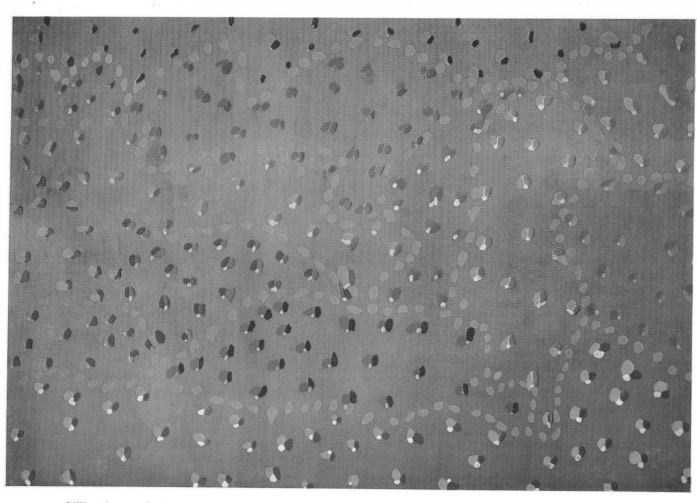

Gillian Ayres In It
Acrylic on canvas 8′ × 12′
Kasmin Gallery

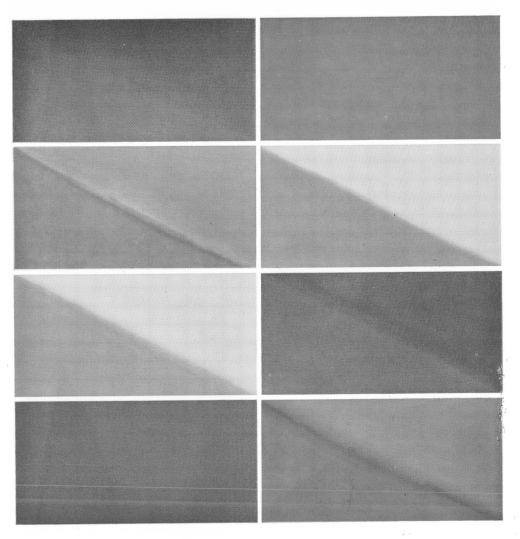

Mark Lancaster Cambridge Red and Green 1968
Liquitex on canvas 68″ × 68″
Rowan Gallery

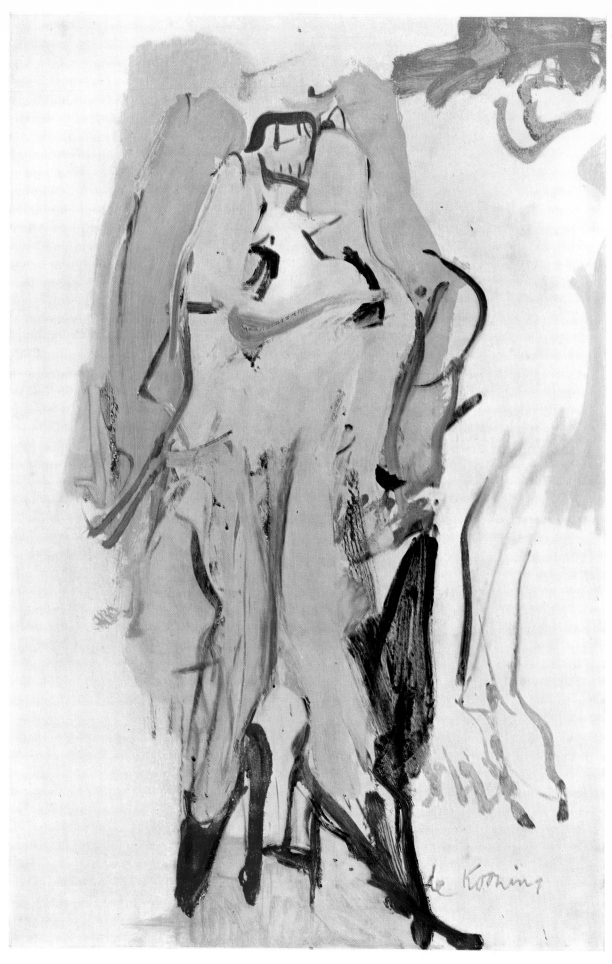

Willem de Kooning Singing Women 1966 Oil on paper mounted on canvas 24″ × 22½″
Courtesy: M. Knoedler & Co., New York *Tate Gallery*

Howard Hodgkin Mr & Mrs Stringer 1966–8
Oil on canvas 48″ × 50″
Kasmin Gallery

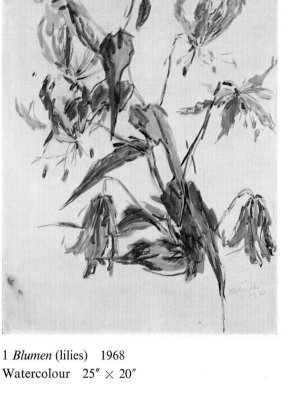

1 *Blumen* (lilies) 1968
Watercolour 25″ × 20″

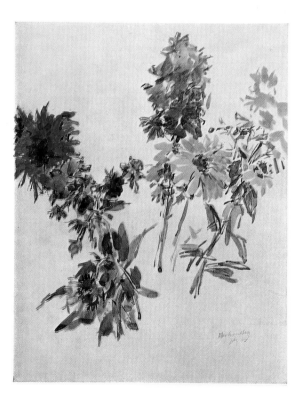

2 *Schildkroeten* (turtles) 1968
Watercolour 25¾″ × 19¾″

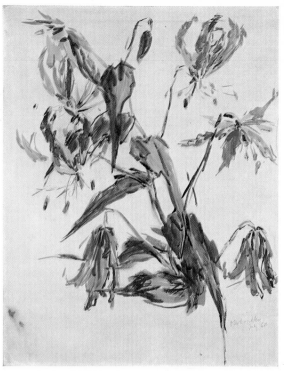

3 *Blumen* (mixed flowers) 1968
Watercolour 25¾″ × 19¾″

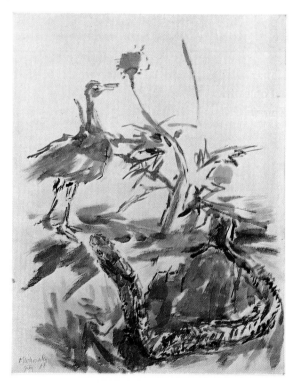

4 *Vogel und Schlange* (bird and
snake) 1968
Watercolour 25¾″ × 19¾″

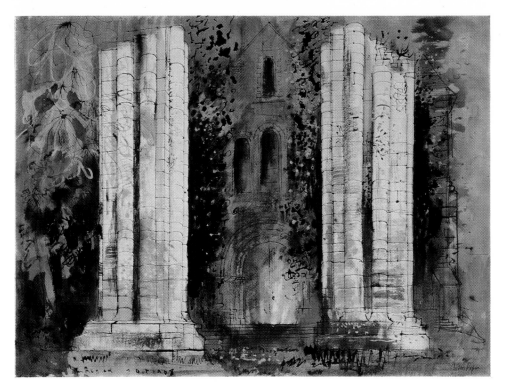

John Piper Reilhac, Dordogne I 1968
23″ × 30″

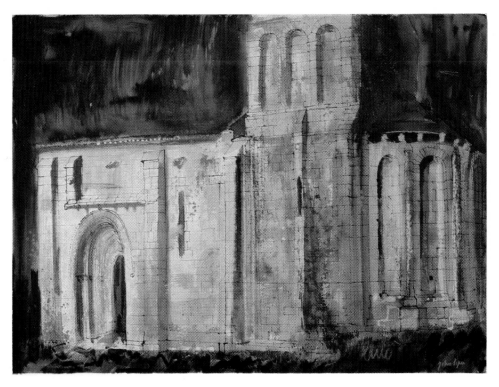

John Piper St Raphael, Dordogne 1968
23″ × 30″
Marlborough New London

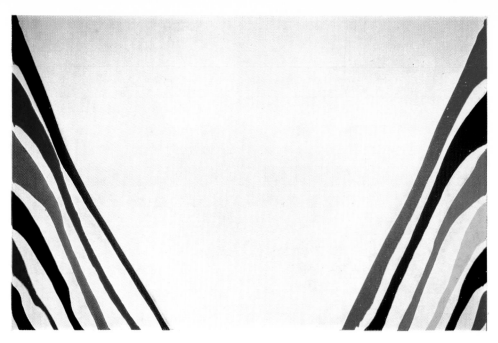

Morris Louis Omicron 1961
$103\frac{1}{4}'' \times 162\frac{1}{4}''$
Waddington Galleries

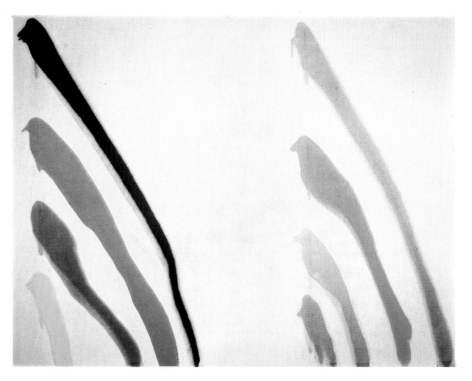

Morris Louis Psi 1960–1
$104\frac{1}{2}'' \times 136''$
Waddington Galleries

Morris Louis *Waddington Galleries*

1 Spring 1962
$78\frac{3}{4}'' \times 19\frac{1}{2}''$

2 Spring 1962
$80'' \times 24''$

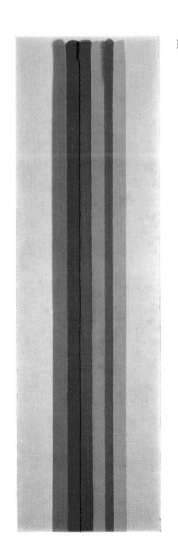 1

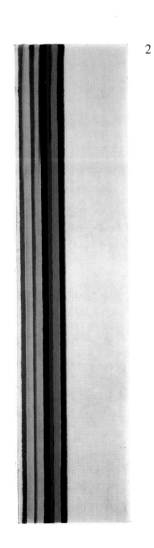 2

Arthur Boyd

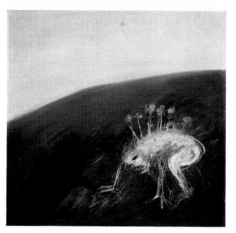

1 Nebuchadnezzar with Flowers in his Back and Black Ram

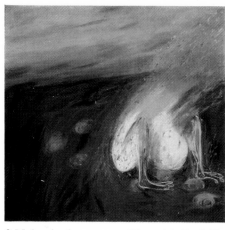

2 Nebuchadnezzar on Fire with Red Sky

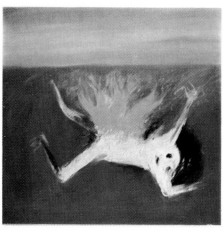

3 Nebuchadnezzar on Fire in a Green Landscape (No 2)*

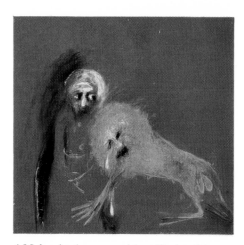

4 Nebuchadnezzar with a Crying Lion (No 2)

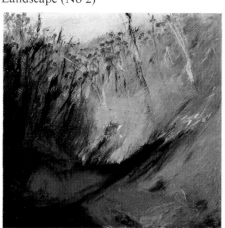

5 Nebuchadnezzar Fallen in a Forest with a Lion (No 2)

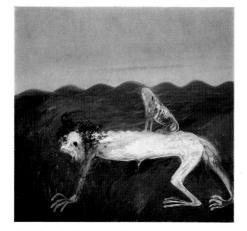

6 Nebuchadnezzar Eating Grass in a Hilly Landscape (No 2)

Oil on canvas 69″ × 72″ *63″ × 72″ 1969
Richard Demarco Gallery, Edinburgh

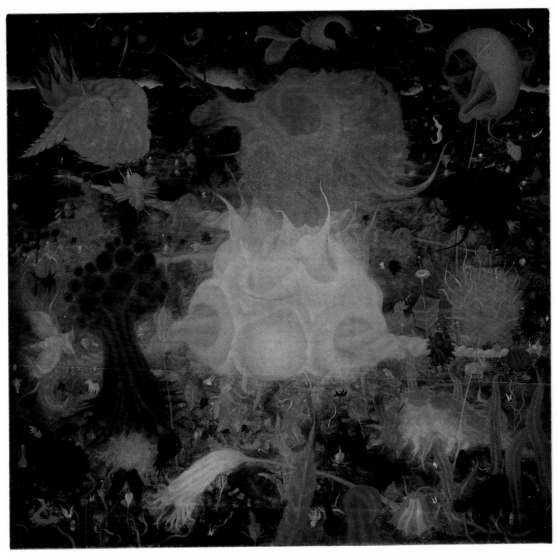

Brauer The Red Headed King 1964 – 5
Oil on board $47\frac{1}{4}'' \times 50''$
Marlborough New London

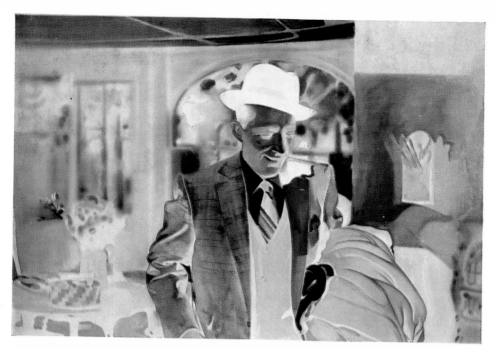

Richard Hamilton
I'm Dreaming of a
White Christmas 1967–8
Oil on canvas 42″ × 63″
Collection the artist
Hayward Gallery

Richard Hamilton
Swingeing London '67 (E)
1968–9
Enamel on canvas and
silkscreen $26\frac{1}{2}″ × 33\frac{1}{2}″$
Courtesy: Galerie Hans
Neuendorf, Germany
Robert Fraser Gallery

Patrick Procktor Eric, Gervase, Ossie 1968–9
Watercolour 31″ × 50″
Redfern Gallery

Helen Frankenthaler Flood 1967
Polymer on canvas 124″ × 140″
Gift of the Friends of the Whitney Museum of
American Art
Collection: Whitney Museum of American Art, New York
Whitechapel Art Gallery

John Hoyland **'12.1.69'**
acrylic on canvas 76″ × 144″

John Hoyland **'20.5.68'**
acrylic on canvas 78″ × 144″
Waddington Galleries

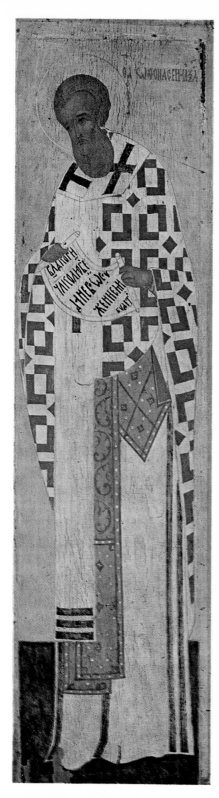

Russian icon, Suzdal school
St Athanasius 15th century
44″ × 12″
Temple Gallery

Ten Important Shows

D

Anthony Caro

Hayward Gallery *January - March*

The unfavourable reception accorded both by London art critics and by the public in general to the new Hayward Gallery on the South Bank was to some extent modified by the retrospective exhibition of sculpture by Anthony Caro, which opened the year's exhibition programme there.

Caro's work, which for the most part ignores the notion of a pedestal or base, proved almost ideally suited to these low-ceilinged and evenly-lighted galleries. One got a real sense of the power of such sculpture to alter one's physical reactions to the space in which it is placed, and Caro was obviously shown to much greater advantage here than in private galleries, which offer much less floor area; or in the open air,

where the impact of these spidery constructions in painted metal is somehow dissipated.

The fact that the Caro retrospective followed close on the heels of the retrospective devoted to the work of Henry Moore at the Tate Gallery in 1968 served to emphasise the importance of the younger man as the pioneer of a new attitude towards sculpture. Caro's first one-man exhibition was held as recently as 1956, at the Galleria del Naviglio in Milan. The work which he showed then bore little relation to anything he has made in the sixties, as one could see from the small handful of early pieces which were included in the Hayward survey in order to document this phase of the artist's career.

In 1960 Caro broke through to a new style. He also changed his allegiances as an artist, and parted from the tradition of Henry Moore in order to follow the very different path pioneered first by the Spaniard, Julio

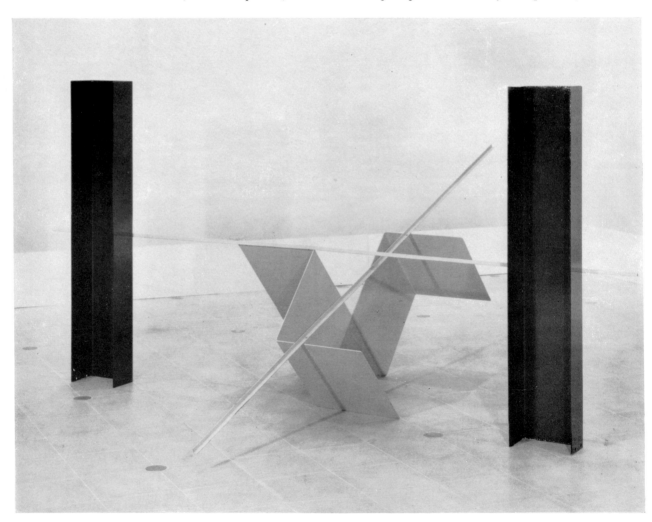

First National 1964 Steel painted green and yellow 9′ 2″ × 10′ × 11′ 9″
Private Collection, Boston

Gonzales, and later by the American, David Smith.

It was at the end of the fifties that Caro first met David Smith himself, and subsequently the important American critic Clement Greenberg. Greenberg has since been one of the most enthusiastic supporters of Caro's work, and has been largely responsible for making Caro's international reputation.

In his Hayward showing, Caro emerged as an extremely complex and indeed ambiguous artist. The tough industrial materials which he uses in his work, the I-beam girders, metal tubes, and pieces of metal sheet and mesh, are the products and necessarily the symbols of an industrial society. Yet Caro, unlike David Smith, does not seem to have his roots in an industrial tradition. His work, for example, very seldom hints at a resemblance either to machinery or to industrial constructions. Rather, it has something tentative and flexible about it. The forms are not forms which fully enclose a volume of space nor are they forms which set themselves up in monumental isolation.

A characteristic Caro sculpture is an object which reaches out hesitantly into the surrounding atmosphere, which sneaks across the floor space or extends a questing feeler towards the ceiling. In fact, this is a lyrical art, made with paradoxically unlyrical materials. Caro seems to extend, almost in spite of himself, the long history of English romanticism, and it is not entirely frivolous to compare his monumental sculptures to, say, a watercolour by David Cox.

Caro has been an immensely important father figure for younger British sculptors, especially those whom he taught at the St Martin's School of Art. One is more than ever conscious after this retrospective that his pupils and followers have been steadily developing away from him in the direction not only of something more industrial, but also of something more urban, uninvolved with ideas about nature which still survive in Caro's work. By making available so large a proportion of the sculptor's total production during the past ten years, the Hayward show rendered a considerable service to the British art scene as a whole. Whether it entirely confirmed that Caro deserved his immense reputation is another matter. Certainly the artist did not emerge from it with increased stature, though his importance in the recent history of sculpture, and indeed of modern art in Britain, is no longer open to question.

(*See colour illustration page 25*)

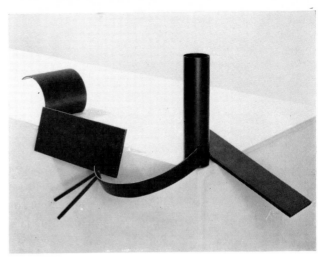

LXI 1968 Steel painted brown 23″ × 45½″ × 14″
Private collection

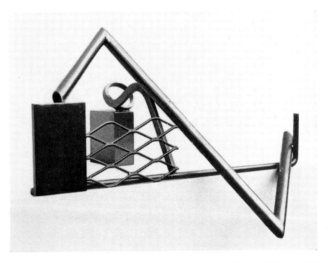

LIX 1968 Steel painted silver grey 11½″ × 17″ × 19″
Collection: T. M. and P. G. Caro

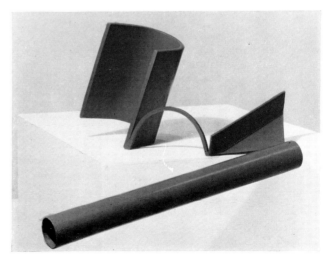

XLIX 1968 Steel painted green 20½″ × 32″ × 25″
Private collection

Willem de Kooning

Tate Gallery *January*

The Sunday Times Colour Magazine, usually an infallible arbiter of all things fashionable, gave the Willem de Kooning retrospective at the Tate perhaps more space than it has ever before devoted to the work of a living painter. It was the more surprising therefore to see the almost universally lukewarm reception accorded to this major retrospective by most of the reviewers. Among the conspicuously half-hearted were Norbert Lynton in the *Guardian*; Edwin Mullins in the *Sunday Telegraph* and Edward Lucie-Smith in the *Sunday Times's* own arts review section.

It is true that the De Kooning retrospective was very much belated. Abstract Expressionism was no longer *à la mode* by the beginning of 1969. Yet De Kooning himself has been widely recognised, not only as one of the pioneers of Abstract Expressionism, but as one of the leading masters of the whole post-war period. Clearly there was something about the show which surprised and disappointed those who were, for the first time, confronted with the full range of De Kooning's work.

It seemed, indeed, that there were two possible attitudes towards his painting. One could either concentrate on the force and liberating impact of a small group of canvases of the 1940s and early 1950s, a group which found its culmination in the vast painting *Excavation*, which dates from 1950, or one could allow one's judgment to be swayed by the work which De Kooning has done more recently.

The retrospective was complete enough to allow even the uninstructed spectator to distinguish a number of phases in the artist's work. There were, for instance, a series of early figurative paintings owing much to Picasso, which mingled the styles of the Blue and Rose periods, with hints taken from Picasso's cubism and surrealism. There were the calligraphic abstract expressionist canvases; the series of women; and the only slightly less extensive series of landscapes. It was the way in which these two latter series developed that gave rise to the greatest unease. The landscapes, very free, and often very bright in colour, were comparable to some of the Turner 'colour beginnings', which hang in the Tate Gallery's own permanent collection. The comparison is not one which flatters De Kooning.

Turner's paintings, however vague they at first appear, always have a coherent structure of lights and darks; De Kooning's landscapes on the other hand have a chaotic quality which bold brushwork cannot always justify.

The series of women presents a case which is more complicated. Early examples can usefully be compared not only to the *Corps de Dame* series by Dubuffet, but to primitive representations of the female form in various cultures, including the graffitti which are seen on the walls of our own cities. De Kooning evidently began by seeking for a kind of harshness which is also present in his non-figurative work, and the way he forces and exaggerates the sexual characteristics of the figure serves to remind us that he is as close to the traditional Expressionism of Europe as to what has now been labelled Abstract Expressionism. Gradually, over the years, De Kooning has sweetened his presentation of the theme. One or two works of the early sixties using collage have been thought of as being related to Pop. The most recent incarnations of this idea, such as *The Clam Diggers* of 1964, actually appear to hark back to the rococo of the eighteenth century. De Kooning, the wild Dutchman, a legend in the New York art world and still more a legend in the painters' bohemia of that city, is here quite candidly a maker of soft-centred chocolates for the rich. The later pictures, painted in the years of De Kooning's immense success, both in terms of money and of prestige, provide a damaging critique of the earlier ones, which begin to seem less admirable when one realises that the passion and anger which they embody could be so easily assuaged.

When he exhibited in London De Kooning was to some extent the victim of a changed social atmosphere which had affected people's view of the artist's responsibility towards the society in which he works. The real reason why Abstract Expressionism now seems so curiously remote is that we see in it the painter's indifference to social values, and his insistence on seeking his own individual salvation. Historically speaking, art has always swung between the two poles of social commitment and its opposite, and the pendulum at the moment is swinging towards commitment. In addition, De Kooning in the years of his success seems to Europeans to embody – even if unconsciously – the social disconnection and social irresponsibility of the United States, which is now his adopted country.

(*See colour illustration page 28*)

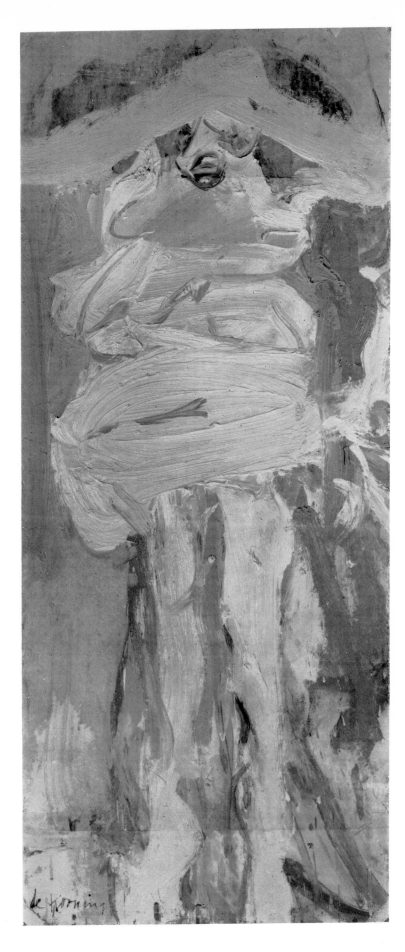

Woman with a Hat 1966
Oil on paper 50″ × 21″
M. Knoedler & Co. Inc., New York

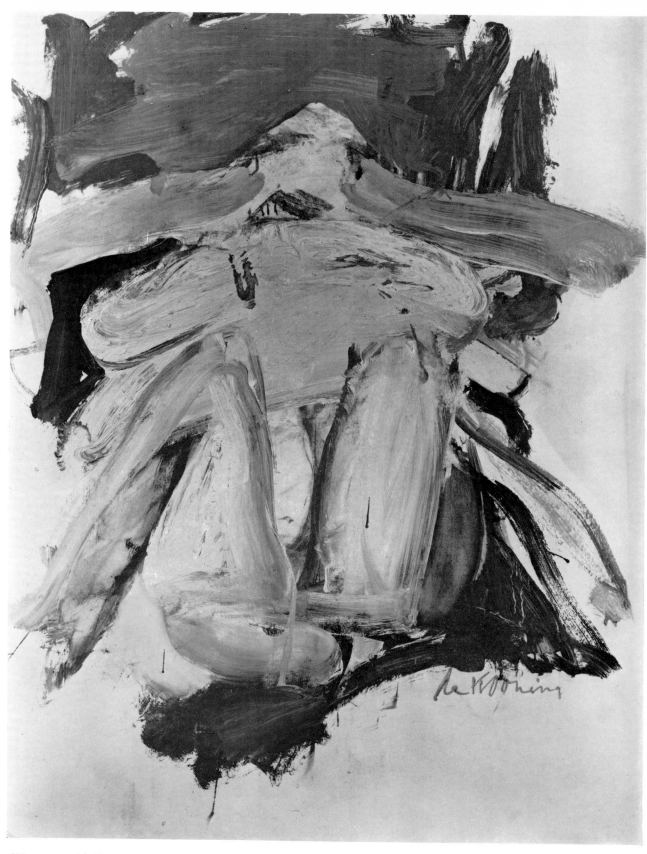

Woman – with Green and Beige Background 1966
Oil on paper mounted on board 28″ × 23″
M. Knoedler & Co. Inc., New York

46

René Magritte 1898 - 1967

Tate Gallery *February - March*

The retrospective exhibition devoted to the work of the Belgian artist, René Magritte, scored one of the really big successes of the year with the London public. Part of the credit for this must certainly be given to the organiser, David Sylvester, who put together a notably well-selected show and saw to it that the relatively restricted number of pictures on view were displayed in a way which allowed one to appreciate each of them to the full. The paintings were hung at varying points along a maze-like structure of screens, which effectively hid them from one another, permitting the viewer solitary contemplation.

Most of the best-known Magritte themes were present in one or other of their versions. Among the works included was Sir Roland Penrose's *Threatening Weather*, subsequently to be among the pictures stolen in the raid on the Penrose collection and afterwards recovered; and

George Melly's well-known erotic painting: *The Rape*.

The enthusiasm of the British public for Magritte would not, one suspects, have been so very great if the time had not been ripe for a retrospective of this sort. In recent years Magritte has been much discussed by a small group of followers, and prices for his paintings have risen steadily in the salerooms. What seems to have prepared the public for a show of this kind, however, was the publicity accorded to Pop art. Magritte's dry, literal technique, the ironic jokes and visual surprises which his pictures contain must strike the enthusiast for Pop as something reassuring and familiar. Magritte's influence has in any case been acknowledged by leading Pop painters, and one of the works in the exhibition was lent by the American artist Jasper Johns. It was particularly interesting in this context to note Magritte's fascination with the 'dead-pan' and the banal object in a picture such as *The Golden Legend*, which shows a whole squadron of French loaves flying through the air like so many Zeppelins.

The appeal of Magritte is not entirely attributable to

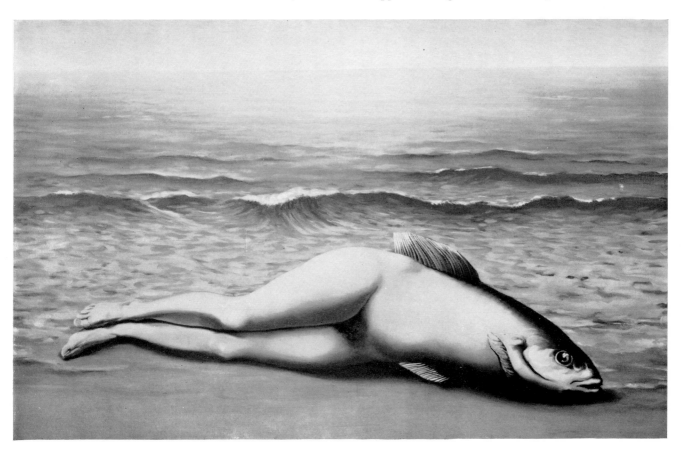

Collective Invention 1935 Oil $28\frac{7}{8}'' \times 45\frac{5}{8}''$
Collection: E. L. T. Mesens, Brussels

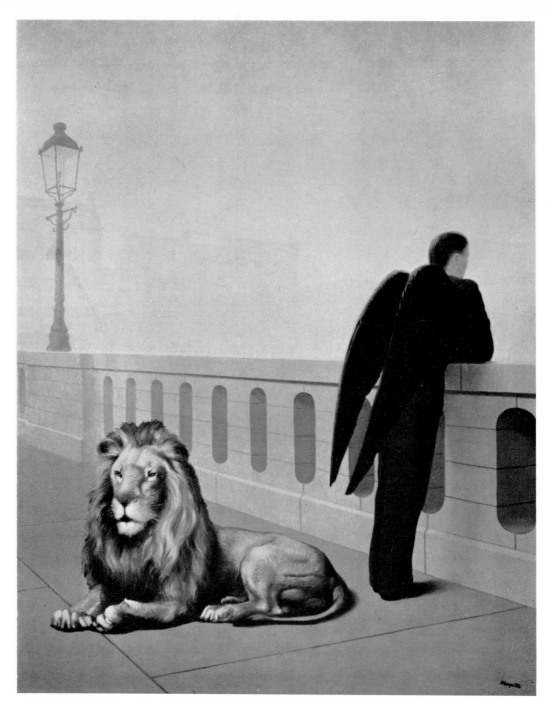

Homesickness 1941
Oil 39¾″ × 32⅛″
Collection: E. L. T. Mesens, Brussels

Pop connections, however, though the comparison does at least give some indication as to where it can be found. What the audience seems to respond to in his work is simply its literalness: Magritte's unaffected willingness to depict realistically scenes and objects and to pack as much dense and definite observation into them as he could. His paintings of humble, everyday things in a setting quite out of context with their usual functions, and those of ordinary people being menaced by their surroundings can disconcert, thrill and even shock, as we read them and grasp their premeditated meaning.

One of the more conspicuous signs of the times in the British art world seems to be an increasing impatience with wholly abstract art. Abstraction is no longer an unfamiliar mode in our galleries, and professional writers on art on the whole are friendly towards it. But the public seems to find less and less excitement in abstract painting, and it looked as if they chose the occasion of the Magritte exhibition to make a protest on the subject.

The contrast between the reception accorded by the public (not the critics) to the Magritte retrospective and to the Ben Nicholson retrospective which followed it some months later was certainly very striking. Nicholson is, after all, one of the hero figures of modern British painting, and one to whom a great deal more critical attention has been paid in recent years than has been given to Magritte.

It is as yet too soon to assess the full impact of this unexpectedly successful exhibition, but one suspects that Magritte will already be making himself felt in colleges of art throughout the country, and his spirit will emerge just as soon as the present generation of young Minimalists has departed.

Magritte's essential 'coolness', his sly wit, are certainly very much in tune with current taste.

The Art of the Real

Tate Gallery *April - June*

This theme exhibition came to the Tate under the auspices of a programme sponsored by the International Council of the Museum of Modern Art, New York, and was arranged by Mr Eugene Goossen, who said in his preface to the catalogue that the show was 'Based on the premise that a significant, identifiable change [had] been taking place in American art in the past few decades'.

The show offered Londoners a slightly belated opportunity to make their acquaintance with what is now described as Minimal art.

It was undoubtedly an important show because it contained a number of milestones in the progress of avant-garde American painting and sculpture towards minimality. Among these were works by Ad Reinhardt, Jasper Johns, Frank Stella and Kenneth Noland. The young lions of the Minimal movement on exhibition with these predecessors included Carl Andre, Donald Judd, John McCracken, Doug Ohlson, Robert Smithson, Sol LeWitt and Robert Morris.

There was also an opportunity to see work by the older, but only recently celebrated, architect-turned-sculptor Tony Smith. His huge piece, *Stinger*, occupied a lot of space on the patch of grass at the side of the Tate. Unfortunately the impact of the exhibition was somewhat muffled by the inclusion of works whose relevance to the thesis seemed doubtful, for instance a painting by, of all people, Georgia O'Keefe.

The exhibition naturally caused a good deal of excited comment among London art critics. In *Art and Artists* Alicia Drweski commented:

One is submerged by the vastness of their monumental scale evoking the feeling of enormous space, and also of emptiness; there are also a unity of style, certain heaviness, a quiet harmony, calm and tranquillity, which probably derive from the barrenness and simplicity of the square shapes, the prevalence of straight, horizontal lines. There are pure colours, pure forms, pure facts, pure objective statements – and what else? Formal variations on certain very limited themes, like the composition of dodecaphonic music. The conventions of 'The Art of the Real' are very strict: no emotion, no stimulations, no associations, no symbols – but alas, no 'magic', no poetry. In the end I do not find these variations of abstract 'minimal' art imaginative or revealing. They are too rigid, too dry, too precise, too monotonous, though these qualities could be seen as virtues.

Norbert Lynton said in the *Guardian* that:

The exhibition proves the opposite to its advertised message. Escape from illusion, purity, absolute literalness, 'the simple, irreducible, irrefutable object' as the catalogue and the poster say – these are in themselves illusory and unattainable. No amount of straight lines and flat colours, of stereometric shapes and mechanical repetition, can stop the living spectator from *using* these works, from engaging his imagination. This is no question of wishing to translate an abstract object into something recognisable; inevitably, for the most part, unconsciously, we respond to it in terms of something else. I don't imply that artists should therefore not even attempt to evade our analogical response – a special sort of intensity does seem to result in the attempt – but rather that there is a basic flaw in the attempt to separate this kind of art as a fundamentally different kind of performance. Art is long; theories and classifications happily die young.

These two opposing viewpoints offer a fair idea of the range of comment evoked. What it will now be interesting to see is the impact which this handsomely presented exhibition has on the work of younger British artists. Most British art schools already fostered, even before 'The Art of the Real' made its bid for attention, small cells of young minimalists who got their information about the theory and practice of this kind of art from the leading American art magazines.

It is as yet too early to see if the presence of the works themselves will make further converts. One suspects not. The exhibition itself had a formidably exclusive air, and one would not blame young artists for feeling that the bandwagon was rolling so fast as to be hardly worth catching.

If Minimal art is to make a large-scale impact in Britain, it will probably be in the guise which it has taken in its second phase – a phase which was well illustrated by the 'When Attitudes Become Form' exhibition which turned up at the Institute of Contemporary Arts at the end of August.

The reason is that, while the argument about Minimality and its functions is essentially sterile, it does serve as a kind of stalking-horse for another and more fruitful argument, which is that about the function of art as environment. In fact, there is a real case for considering Minimal art simply as aberrant architecture – this was a point which might well have been made at the Tate.

Donald Judd Untitled 1965

Galvanised iron 14′ 4⅜″ × 40¼″ × 31⅛″

(10 boxes each: 9⅛″ × 40¼″ × 31⅛″ at 9″ intervals – only 7 pieces shown)

Gordon Locksley Gallery, Minneapolis, Minnesota

Helen Frankenthaler

Whitechapel Art Gallery *May - June*

The retrospective exhibition devoted to the work of Helen Frankenthaler at the Whitechapel Art Gallery had the merit of allowing the London public to see, and at long last in sufficient quantity, the work of an artist who occupies a pivotal position in the recent history of American painting. The claim made by E. C. Goossen in his catalogue introduction that Frankenthaler was the inventor of the 'soak-stain' method of painting has recently been contested – the credit apparently belongs to her compatriot, James Brooks. Nevertheless, Frankenthaler's impact on Morris Louis and the colour painters who follow Louis's footsteps is incontestable, and our understanding of American art was much enlarged by being able to see what Frankenthaler had been doing for a number of years. Among the paintings included in the show, for example, was the *Mountains and Sea* of 1952, which had made such an impression on Louis and on Kenneth Noland when they saw it in her studio.

No artist, however, can survive merely on grounds of historical importance, and the Frankenthaler show would have been a barren occasion indeed if all it served to do was to correct our perspective on recent American art. Though one did not meet with an artist of absolutely the first rank at the Whitechapel, this was an impressive exhibition, quite able to justify itself on grounds of aesthetic pleasure alone.

The reaction of leading London critics was not only remarkably enthusiastic, but also remarkably engaged and perceptive. Guy Brett wrote in *The Times* of 26th May 1969:

Frankenthaler has a remarkable ability to let colour float with its own buoyancy in a painting. And its buoyancy becomes most telling when the free shapes are playing with the lurking presence of a formal structure. One of the fine paintings, produced in the early sixties (which I think are her best), is called *Vessel*, a title which aptly describes the way the raw canvas holds the edgeless pools of colour. And in the 1964 paintings a symmetrical and emblematic format is subjected to a kind of painterly sea-change – which makes its formality truly enigmatic.

The American critic Gregory Battcock wrote in *Art and Artists*:

Proof rather than faith is the earmark of modern man. It therefore must be the concern of the artist and it is the major concern of Frankenthaler. We are asked to believe only in what we see, and we see everything. Since we cannot believe anything we do not see, the artist has wisely kept the un-seen out of her pictures. In other words, there is no over-painting either – at any rate, no over-painting that cannot be seen *through*. In her paintings over-painting is there not because the artist has attempted to disguise something but because she is *illustrating* something. Since, to this artist, disguised information is worse than no information; it is information that is misleading and hinders orderly reception; it has been avoided wherever possible.

The fact that these pictures are nice to look at is almost irrelevant. Their subtle compositional agitations are merely games that delight, perhaps surprise, possibly sooth the viewer; they seem to suggest that perhaps, after all [in] the honesty, soul searching and existential struggle, everything is all right – perhaps even better for it. The artist recognises (and herein lies her technical professionalism) that certain colours, shapes, juxtapositions and transparent overlays combine to compliment practical discoveries concerning the essential subjects of painting itself on one hand, and provide for a dignified, surprising yet utterly logical pictorial scheme, on the other.

It does not seem necessary to add a great deal to these comments, though it is interesting to note than in 1969 Frankenthaler's art was so exactly adjusted to the tastes and indeed to the preconceptions of those who were most informed about the modern art scene in London. It takes nothing away from the real merits of Frankenthaler's paintings if we say that the reception accorded to her work supplied an interesting example not only of the sympathy which exists between the British and American schools of painting at the present moment, but also of the continuing artistic dependence of London upon New York.

Seen in London, Frankenthaler's pictures seemed remarkable not only for their dexterity and elegance, but for a kind of self-confidence which is often missing from the work of British painters of the same generation. Her painting is not assertive because it does not have to be. Though she is busy developing the idiom of painting, she knows that she has an audience upon which she can rely to sympathise with what she is doing. The playfulness which appears in some of the work is a product of this sense of ease and relaxation; the hedonism which mars some of De Kooning's recent painting is here met with in much more acceptable guise. The airy gestures which she makes upon the canvas signal to us the dominance of American culture. (*See colour illustration page 38*)

Island Weather II 1963
Oil on canvas $93\frac{1}{8}'' \times 58''$
Collection: Mr and Mrs Howard Sloan, New York
Photograph: Geoffrey Clements

Ben Nicholson

Tate Gallery *June - July*

The Ben Nicholson retrospective at the Tate was a tribute to one of the most important senior British modernists (it served to celebrate his 75th birthday). The exhibition contained 127 items, and was thus the most comprehensive showing yet given to the artist's work.

Nicholson himself was responsible for the selection, which tended to emphasise some aspects of his career at the expense of others. The early work of the 'twenties and 'thirties was especially well shown, and so were recent paintings and reliefs.

Critical reaction was predictably complimentary. Nigel Gosling remarked in the *Observer*:

Anybody interested in painting can spot a Nicholson within 50 yards, with its severely ordered rectangles and circles, and subdued, well-weathered colouring. It is good to see the whole range displayed, from the early works with their Christopher Wood-ish charm to the large late ones which, though done in Switzerland, still seem faintly briny from the air of St. Ives. All have Nicholson's personal trade mark – a precise yet flexible economy which amounts to a mathematics of feeling.

This was a fair and reasonable statement of the established English viewpoint about this painter, whose achievement it has been to sum up with uncanny accuracy most of the virtues and some of the defects of cultivated English taste.

The early paintings at the Tate were indeed fascinating, not only in themselves but for what they said by implication about English culture. Nicholson comes of a family of painters and the relationship between his own work and that of his father, Sir William Nicholson, is close. Sir William Nicholson's marvellously refined still-lifes, a re-creation of the spirit of Chardin in the terms of the Edwardian age, are one of the prime sources for much of his son's earliest work. But one finds too an intelligent study of Cézanne and the Cubists, and a cunning use of things learnt from the *faux-naif* painter, Christopher Wood.

Though the elements in the amalgam are clearly distinguishable, the mixture itself has charm and style. Later, in the 'thirties, Nicholson grew more ambitious and was particularly influenced by Braque. He had now begun to think of himself as competing on the international scene, and the introduction to the Tate catalogue (obviously written very much under the painter's own influence) notes that: 'During the mid- to late-thirties, Nicholson's work was shown in a number of important international exhibitions on equal footing with Calder, Gabo, Giacometti, Miró, Mondrian and others, and their work in turn began to be shown in London.'

Towards the end of this decade Nicholson was certainly as much of an international figure as he was ever to become. He was closely associated with the distinguished refugees who gravitated towards London, among them Gabo, Moholy-Nagy and Mondrian.

The Tate exhibition, nevertheless, seemed to indicate that Nicholson's ambitions to be a universally recognised international master had not been fulfilled despite the number of foreign public collections which possess and exhibit his work. The white reliefs of the 'thirties and later, which are still among the most characteristic of Nicholson's productions, show him as a man of enormously refined sensibility rather than of genius.

The ravishing drawings which were among the chief delights of the exhibition reveal just how English Nicholson has remained. The architectural ones in particular belong firmly in the English topographical tradition. Part of the charm of these drawings and of the reliefs is to be found in their tremendous technical skill. Like his father, though in a more inventive fashion, Nicholson is a master craftsman with the materials which he chooses to employ. The fact that one immediately notices these technical subtleties does, however, imply that there is a lack of real formal inventiveness in much of Nicholson's work.

It seems probable, on the evidence of the Tate retrospective, that Nicholson's real place in the history of art of the twentieth century will be as an important figure in an essentially provincial context.

This is something which also has to be said about the majority of the English painters of the past. It takes the force of genius to revolutionise a cultural context, and force is not Nicholson's strong suit. If one compares him with Henry Moore, for example, one sees that Nicholson is seldom as bad as Moore can sometimes be, but also that an unsuccessful work by Moore has a sharpness of individuality which Nicholson seldom achieves. At the deepest level, Moore creates, while Nicholson deploys a creative sensibility – a rather different king of activity. (*See colour illustration page* 65)

October 1954 (Rievaulx)
Oil wash and pencil on paper $22\frac{1}{2}'' \times 15\frac{1}{4}''$
Collection: Margaret Gardiner

1945 (Still life with 3 mugs)
Oil and pencil on board $16'' \times 5\frac{1}{2}''$
Private collection

Edvard Munch 1863 - 1944 and
Emil Nolde 1867 - 1956

Marlborough New London

Marlborough Fine Art *July - August*

Edvard Munch and Emil Nolde only met once in their lives, in Berlin in 1907. Nolde afterwards noted in his memoirs that the two artists scarcely spoke to each other on this historic occasion. The Marlborough's double exhibition had as its ostensible purpose the desire to demonstrate that there was a greater parallel between the two artists than history might suggest. Martin Urban wrote in a catalogue essay that:

. . . one senses a closer relationship between Nolde and Munch than with the other German Expressionist painters. For all his directness in tackling reality, Nolde's landscapes have something of the dark melancholy resonance of the North. His figures, often placed in the deliberate antithesis of a double-figure composition, reveal an awareness of the secret nuances of psychology, which elsewhere can only be found in Munch.

Urban was forced to admit, nevertheless, that the two artists inhabited different worlds. The confrontation was, as most British critics seem to agree, a triumph for the Norwegian. Paul Overy wrote in the *Financial Times* that, 'the juxtaposition demonstrates just how much finer a painter Munch was than Nolde'. He went on to define some of the differences:

In Nolde's paintings you find all the gesture and surface drama associated with intense emotion: the rolling eyes and contorted limbs and faces; but no sense is conveyed of what caused them. Nolde completely lacks any psychological insight. In front of a Munch you feel that you are looking *into* the minds and emotions of his distraught or anxious figures. Nolde presents a surface turmoil which tells you nothing of the nature of the feelings he is trying to express.

The main point of the show was not so much the comparison, but the mere fact that it brought a considerable quantity of Munch's work to London. Few British art lovers, unfortunately, can have the good luck to experience the splendours of the Munch museum in Oslo, which represents the artist even more completely than the Turner Bequest represents Turner at the Tate Gallery and the British Museum. The material on view at the Marlborough was mostly drawn from the great collection in Oslo, and, since Munch is an artist who tends to repeat his theme, it was by no means unworthy as a representation.

The prints, in particular, gave a very complete and rich idea of Munch's capacities in the graphic medium. Anyone encountering the artist for the first time in this particular show, must have felt himself or herself to be in the presence of a master.

The impressive thing about Munch as a graphic artist is the extreme freedom and flexibility with which he uses the medium. These are prints which break all the rules: Munch has gone beyond conventional technique. Nor is he content, having established how a particular result is to be obtained, simply to run off an edition. As each print is created on the press, he varies the inking, tries different combinations of colour, alters the block or the stone. Each print is therefore unique. The Munch Museum in Oslo sometimes makes exhibitions from its holdings which show the successive states of a particular image, and one hopes that one day it may be possible to have a display of this kind here. But certainly the Marlborough show offered pleasures enough, and whetted the appetite for a larger show, on a scale such as only a national museum could manage.

(*See colour illustrations pages 70 and 71*)

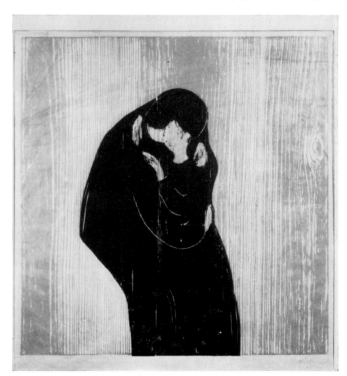

Edvard Munch The Kiss 1902
Woodcut $17\frac{1}{2}''$ × $17\frac{1}{2}''$
Marlborough Fine Art

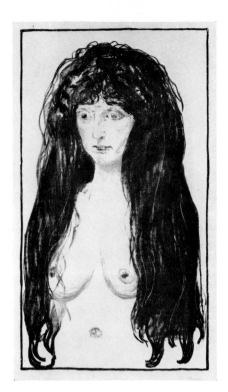

Edvard Munch Sin 1901
Lithograph $19\frac{1}{2}'' \times 15\frac{1}{2}''$
Marlborough Fine Art

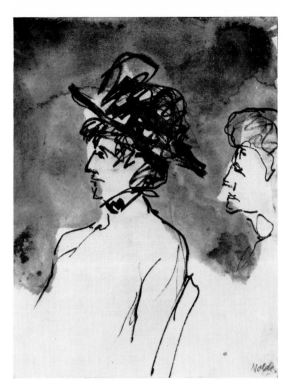

Emil Nolde Portrait of a Lady (undated)
Watercolour $6'' \times 4\frac{7}{8}''$
Marlborough New London

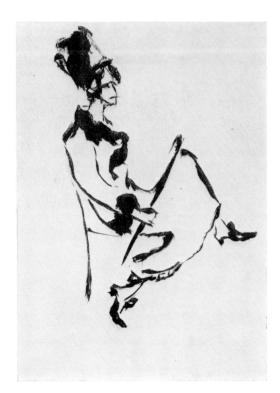

Emil Nolde Seated Woman 1911
Lithograph $7'' \times 5\frac{1}{8}''$
Marlborough New London

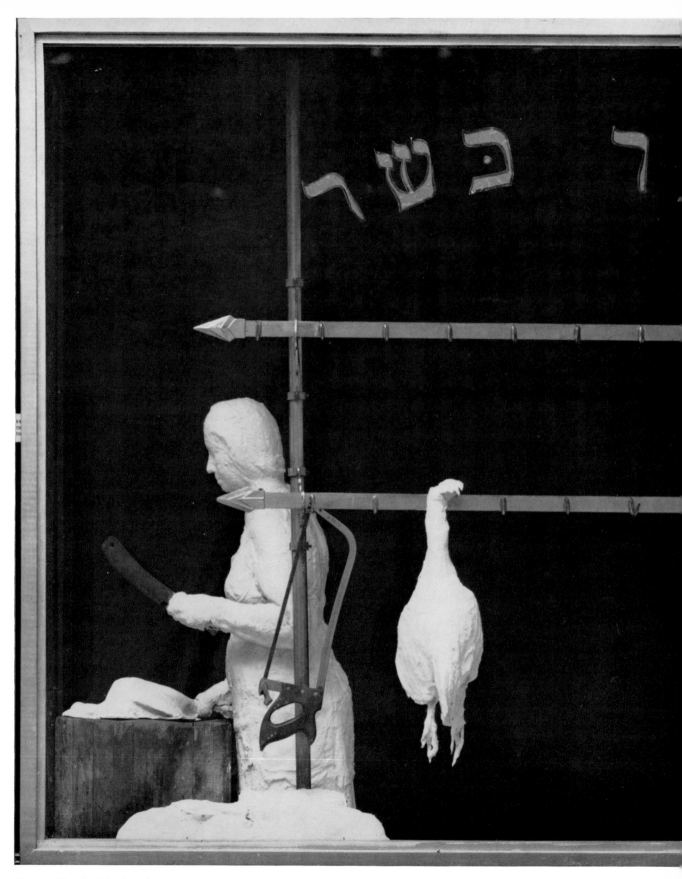

George Segal The Butcher Shop 1965

Plaster, chrome, wood and plastic 93½″ × 99″ × 48″

Collection: Art Gallery of Ontario, Toronto

58

Pop Art

Hayward Gallery *July - September*

The 'Pop Art' exhibition, organised by the well-known British art critic, John Russell, and the American critic and painter, Suzi Gablik, was an ambitious attempt to take a new look at an art movement which for the past couple of years has generally been written off as defunct.

Unlike previous showings of Pop, this was academic in its intentions and carefully categorised. Most of the divisions chosen were divisions by subject matter – one large section was devoted to food, for example, and another to pop singers. This was perhaps a little paradoxical when one of the avowed aims of the organisers was to demonstrate the connection between Pop and Minimal art. Another aim of the exhibition, perhaps not wholly conscious, seemed to be to demonstrate the inferiority and, in particular, the self-indulgence of British Pop when compared with the American variety. Miss Gablik makes this particular point again in the interesting book which Messrs Thames & Hudson published to coincide with the show.*

The reaction of London critics to what they admitted to be an important exhibition was somewhat confused. Perhaps one reason for this was the fact that they had, thanks to a plethora of exhibitions in the past, been invited to write about Pop in so many contexts. Dr Roy Strong, Director of the National Portrait Gallery, writing in the *Sunday Times*, said:

It is useful if difficult to try to put Pop into some sort of historical perspective. In the future, I would think that it will be looked back on not only as a coherent style in painting and sculpture but, in the same way as Art Deco or Art Nouveau, as a style which embraced the allied arts of interior decoration, book design, advertising, theatre decor and clothes. It is a pity that the overall impact is not at least demonstrated in this exhibition even though the organisers may have felt reluctant to have included Carnaby Street pop tat. Surely much of its significance lies in the fact that Pop is a recognisable period style if one accepts an umbrella definition of it as against the more taut pronouncements of its exponents and critics.

Nigel Gosling, of the *Observer*, was rather more enthusiastic:

* *Pop Art Redefined*, by John Russell and Suzi Gablik, Thames & Hudson, 1969.

This up-dating of our pictorial imagery amounts to the birth of a new language; and a new language means a new literature. There are things stated at the Hayward which have never been stated before, and could not have been. Though probably as offensive to some as the Bible, it has the enormous charm of intelligibility, combined with the joys of mild shock and occasional puzzlement.

He went on to say, nevertheless, that he had reservations both about the exhibits and their display, and deplored 'an unhealthy whiff of nostalgia', as well as saying that he found the contents of the show 'a little sentimental and parochial'.

A third reviewer, Guy Brett of *The Times*, found the show 'rather thin on the ground', and thought that the system of categorisation tended to destroy 'the sense of context which plays a large part in the work of Pop artists'.

The reaction of the public was wholeheartedly enthusiastic, and the crowds of visitors who flocked to see the show did much to support Dr Strong's contention that Pop is more essentially a life style than an art style.

Envisaged, perhaps, as a high-class embalming operation, 'Pop Art' turned out to be one of the liveliest art events of the year under review, and during the period of the exhibition a visit to the Hayward would have enabled any stranger to the city to focus very exactly on some of the elements which gave a new flavour to the London life of the sixties.

(*See colour illustration page 36, top*)

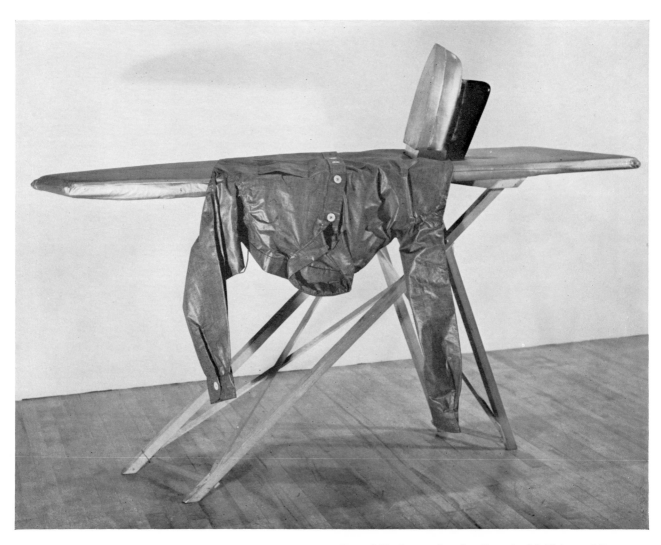

Claes Oldenburg Ironing Board with Shirt and Iron 1964
Vinyl, nylon, wood and plaster 80″ × 67½″ × 24″
Collection: Mr and Mrs Michael Sonnabend, Paris

'When Attitudes Become Form'

Institute of Contemporary Arts

August - September

This was the least encouraging yet probably most significant art phenomenon of the year. Charles Harrison refurbished for its London showing an exhibition put together by Harald Szeemann and the first seen at the Kunsthalle, Berne, earlier in the year. The refurbishment chiefly consisted of the addition of works by a number of British artists. Mr Harrison described the show in a catalogue introduction as: 'the first opportunity for real acquaintance in this country with certain international developments which have been the subject of a series of group showings in America and the Continent over the past two years.' More specifically, this was the first proper showing given in England to the second, or 'anti-form', phase of Minimal art, and it followed hot on the heels of another exhibition which put the beginnings of the style into some kind of perspective ('The Art of the Real', Tate Gallery, 1969).

Harald Szeemann's introduction made 'When Attitudes Become Form' perhaps more comprehensible than the exhibits themselves. He said in part:

. . . nowadays the medium no longer seems important in the newest art. The belief in technology has been superseded by the belief in the artistic process. The major characteristic of today's art is no longer the articulation of space but human activity, the activity of the artist has become the dominant theme and content.

He also added:

A large group of artists, like the 'Earth Artists', are not represented by works, but with information; and the 'Conceptual Artists' are represented by working plans, which no longer require further realisation. This conceptual art readily makes use of existing systems (telephone, post, press, cartography) to create its works, and these eventually lead to new systems, which prevent all discussion of their starting points.

The stern warning given by implication in this must nevertheless be ignored. By trying to eliminate all the usual disciplines imposed upon the artist by his effort to create a work of art which has an objective existence quite separate from himself, the contributors to 'When Attitudes Become Form' managed to produce an exhibition of quite outstanding dreariness, at least from the visual point of view. It is a moot point whether sufficient intellectual excitement was generated (mostly by the labels and catalogue entries elucidating the works) to compensate for this.

At the same time, it was necessary to recognise that here was a good map of the kind of territory being explored and occupied by the extreme avant-garde at the present moment.

Many younger British artists clearly feel a fascination for the ideas which the exhibition attempted to embody.

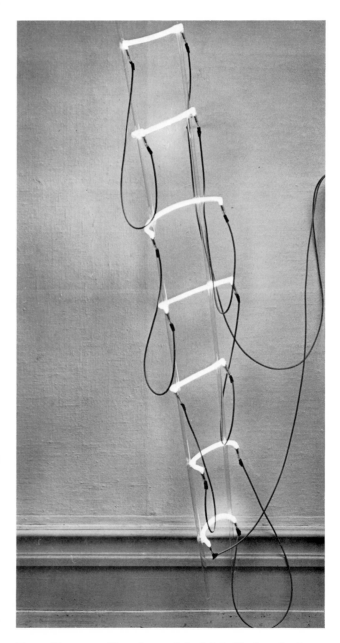

Bruce Nauman Templates of the left half of my body 1966
Neon tubing 70″ × 9″ × 6″

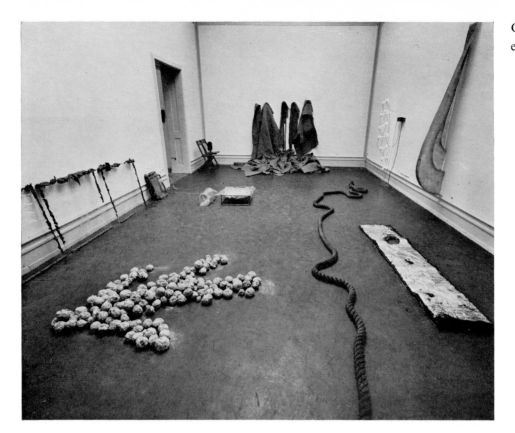

General view of
exhibition, Berne location

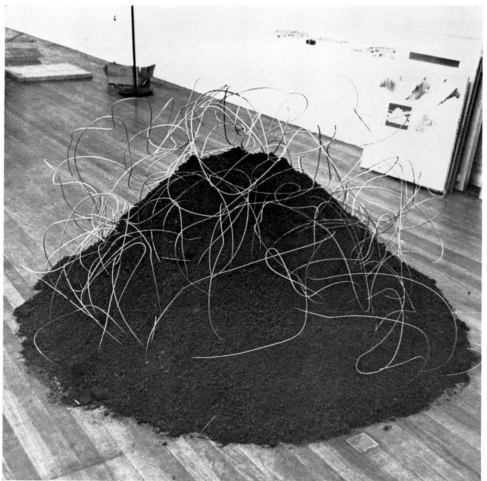

Reiner Ruthenbeck
Aschenhaufern V 1969
Ashes and wire
60″ diameter
**Institute of Contemporary
Arts**

'Abstract Art in England 1913 - 15'

d'Offay Couper Gallery

November - December

Astonishingly, this was the first exhibition devoted to the work of the Vorticists and their peers to have been held in England since 1915. But fortunately, it was an exceedingly scholarly one, with a thorough catalogue which will certainly become much sought-after. The emphasis was placed on the group's theory of 'expressing in non-representational terms abstract concepts of energy, force and mechanics', to quote Anthony d'Offay in the catalogue introduction. The aim was to assess a unique and rebellious movement which took place in English art just as the First World War was about to begin, and which was then checked by that catastrophe. D'Offay goes on to admit, however, that 'if today we consider the movement in terms of abstraction, this was certainly not the preoccupation of the critics at the time'.

The Vorticists, headed by Wyndham Lewis, David Bomberg, Henri Gaudier-Brzeska, William Roberts and Edward Wadsworth, were judged then as followers of the Cubists and the Futurists, whose works had already been shown in London before 1913. But d'Offay's claim is that, in moving towards total abstraction, the Vorticists and others went beyond their mentors the Futurists and Cubists; and he calls attention to the importance of English sources for the new art – notably the British Fauves around J. D. Fergusson, and the Omega Workshop of Roger Fry. He concludes that 'for two brief years . . . England produced a group of painters whose discoveries in abstract art could, as a movement, rival anything in Europe.'

A study of the works on view supported his claim. These jumping, flickering, geometric shapes were rhythmic abstractions inspired by the new industrial environment (its architecture and its machines) which so excited the artists. There was no analytical taking apart of the static object here; neither was there any evidence of the blurred, multi-images of much Futurist work, but rather a complex of lean, hard-edged, zig-zagging patterns. As Edwin Mullins in the *Sunday Telegraph* put it:

The Vorticists, like the Italian Futurists whose work they knew, set about formulating a kind of visual jazz capable of expressing the *soul* of the 20th century.

However, he went on to add a reservation:

. . . I'm inclined to believe Vorticism ran its full course; that, as in the case of Cubism, the war came more as undertaker than as murderer.

Nevertheless, as few exhibitions have been able to, this one altered our conception of art history, and the development of modernism in particular. It is of especial interest that it was staged by a dealer at a private gallery.

The relatively modest nature of the exhibits, which were mostly drawings, could not disguise the explosive force of the ideas about art which they embodied. The real puzzle is to say why the movement died so swiftly – as Edwin Mullins noted, the War alone was not to blame: the artists seemed to exhaust their own vitality, to be unable to keep things at such a high pitch of inventiveness for long. The subsequent careers of some of them seem to demonstrate this.

(*See colour illustration page 81*)

Laurence Atkinson Abstract Composition
Pencil and coloured crayon $31\frac{1}{2}'' \times 21\frac{1}{2}''$

David Bomberg Study for 'The Mud Bath' 1914
Gouache $17\frac{5}{8}'' \times 26\frac{3}{4}''$

Ben Nicholson 1944 (Relief project)
Oil and pencil on paper and wood $7\frac{7}{8}'' \times 7\frac{7}{8}''$
Private Collection
Tate Gallery

Pierre Bonnard Jeune femme cousant *c.* 1905 – 10
Oil on canvas 19″ × 25″
Arthur Tooth & Sons

E. Vuillard *Le déjeuner à Villeneuve sur Yonne* 1897
Oil on board $12\frac{1}{4}'' \times 21\frac{1}{4}''$
Arthur Tooth & Sons

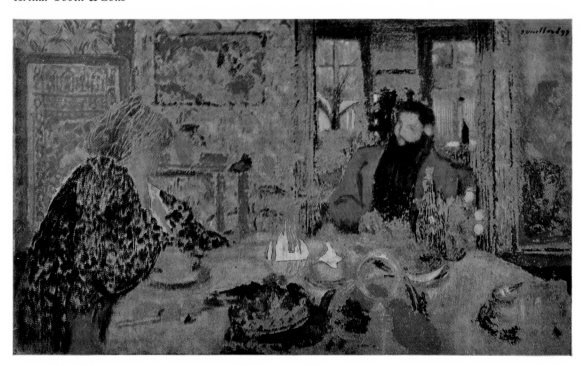

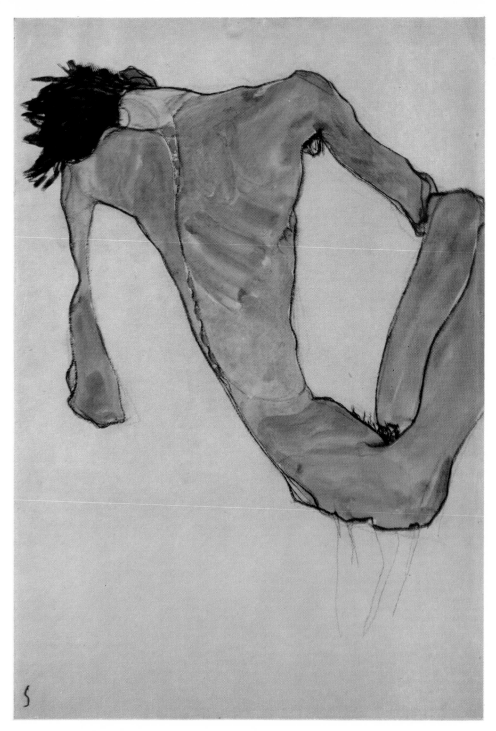

Egon Schiele Male Torso (Back View) *c.* 1911
Watercolour $17\frac{3}{4}''\times12\frac{3}{8}''$
Marlborough Fine Art

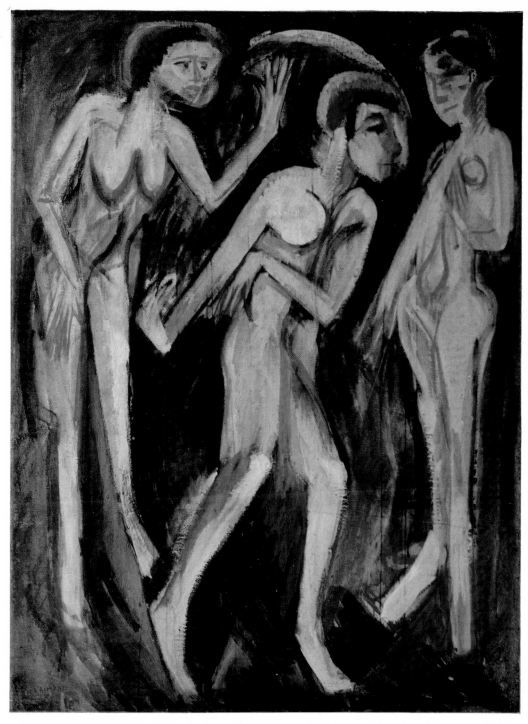

Ernst Ludwig Kirchner Dance between the Women 1915
Oil on canvas $47\frac{1}{4}'' \times 35\frac{1}{2}''$
Marlborough Fine Art

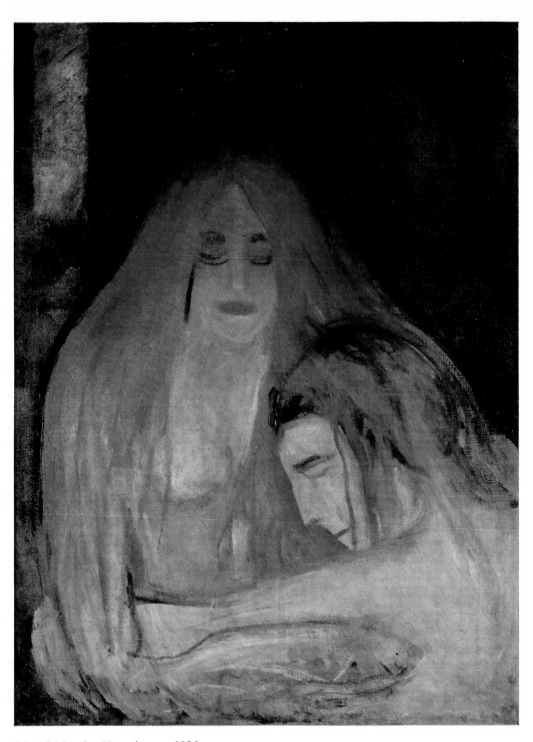

Edvard Munch Vampire *c.* 1896
Oil on canvas $33\frac{3}{4}''$ × $26\frac{3}{4}''$
Marlborough Fine Art

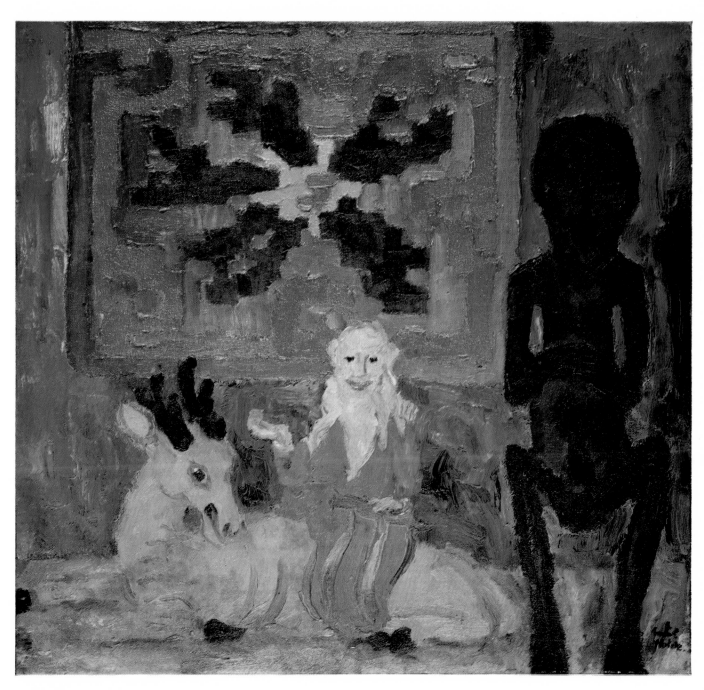

Emil Nolde Still Life E *c.* 1914
Oil on canvas $28\frac{3}{4}'' \times 31\frac{1}{4}''$
Marlborough New London

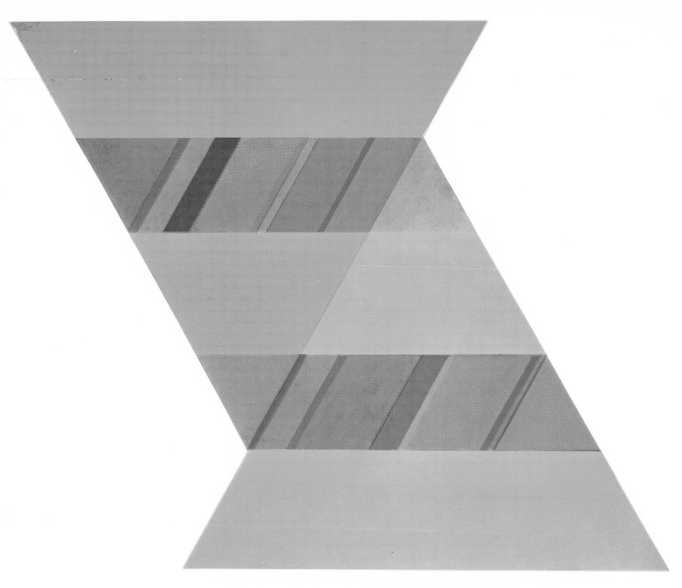

Michael Tyzack Madigan 1969
Acrylic on cotton duck 93″ × 116″
Richard Demarco Gallery, Edinburgh

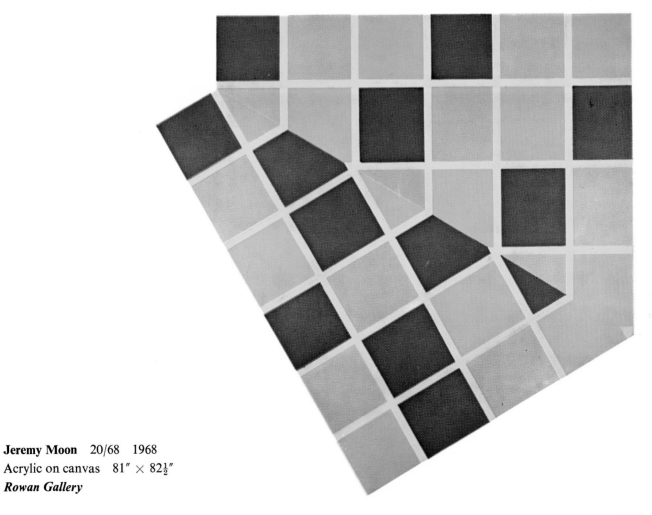

Jeremy Moon 20/68 1968
Acrylic on canvas 81″ × 82½″
Rowan Gallery

Tess Jaray Encounter 1968
Oil on canvas 84″ × 84″
Axiom Gallery

Bridget Riley Orange, Violet and Green Elongated
Triangles 1969
Emulsion on canvas 80″ × 133¼″
Rowan Gallery

Victor Pasmore Brown Development No. 3 1964–5
Oil on board 66$\frac{1}{4}$″ × 48″
Marlborough New London

Charles Biederman Structurist work No. 35
1959–64 Red Wing
Painted aluminium 48″ × 37″ × 9″
Hayward Gallery

Henry Inlander Summer River No. 1
Oil on canvas $58\frac{1}{4}'' \times 78\frac{1}{2}''$
Roland, Browse & Delbanco Gallery

Edward Middleditch Sea Flower 1969
Acrylic on paper $31\frac{1}{2}''\times 40''$
New Art Centre

Mario Dubsky Roland 1965–8
Oil on canvas 84″ × 84″
Grosvenor Gallery

Wyndham Lewis Composition in Blue 1915
Ink, crayon and watercolour $18\frac{1}{2}'' \times 12''$
d'Offay Couper Gallery

Anthony Green Altadena/Margaret Croxford's Dream
1969
Oil on board 76″ × 48″
Rowan Gallery

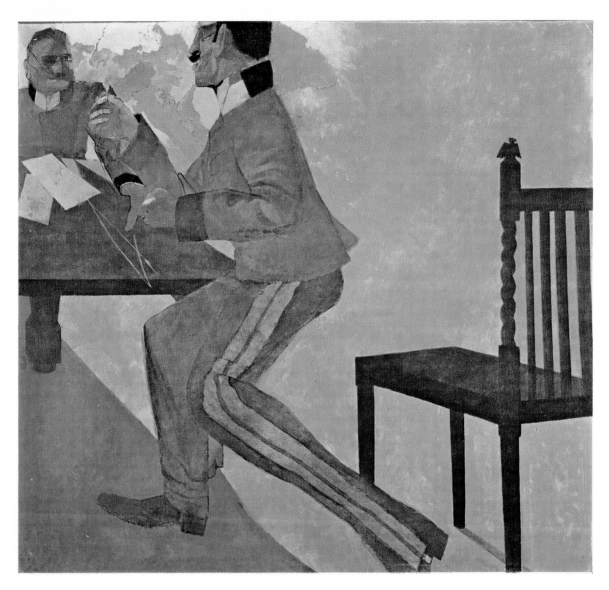

Leonard Rosoman The Promotion No. 2
(Act 1 Scene 2)
Oil on canvas 4′ × 4′
Roland, Browse & Delbanco Gallery

Richard Smith Riverfall 1969
Oil and acrylic on canvas $78'' \times 270'' \times 16''$
Kasmin Gallery

Activities of the Year

Five Light Artists

Greenwich Theatre Art Gallery

January - February

The Greenwich Theatre Art Gallery is a new, Art
Deco-Gothicky building squeezed narrowly between a
pub and a row of Georgian houses at the foot of
Crooms Hill in Greenwich, SE10.

The Gallery's off-off-London position can be
daunting to a prospective visitor without his own
transportation, but nevertheless it is worth the journey,
as few other galleries during 1969 have had such an
imaginative programme of exhibitions. This gives
opportunities to talented newcomers, who are allowed
to use the gallery space with complete freedom.

In January, an experimental Light Show was put on
by a group of known and not so well-known artists.
They were: painter Peter Sedgley – his kinetic, airbrush-
painted 'target' pictures here progressing logically into
revolving, fluorescent-coloured discs; Bill Culbert and
Stuart Brisley – both of whom were to create special
pieces for the 'Environments Reversal' exhibition at
Camden Arts Centre later in the year; Don Mason and
Steve Willats. Each artist's contribution was highly
individual in concept, well thought through and
professionally carried out. An extremely stimulating
show in a medium still strangely neglected in Britain.
For example, we have no gallery in London or the
provinces to compare with Galerie Denise René in
Paris, or the Howard Wise Gallery in New York.

Don Mason Programmed Light Construction No. 7a
(detail) 1968
Perspex sheet/rod, motor, light and wood
7′ 6″ × 1′ 6″ × 9″

Stuart Brisley Untitled 1968–9
Perspex, nylon and light 29″ × 29″ × 30″

Bill Culbert Blaze Station 1968–9
Metal rods and light 8′ × 8′ × 8′

86

Tim Scott

Museum of Modern Art, Oxford

March 4 - April 12

Waddington Galleries *December*

Tim Scott's two shows, one in Oxford and one in London, presented a similar range of sculptural ideas, and pieces from the 'Bird in Arras' series were to be seen in both exhibitions. The points of interest about the sculptures were first of all their extreme open structure. The second point was the use of colour, about which the sculptor offered some interesting thoughts in his Oxford catalogue notes:

The use of colour surfaces in sculpture is an expression of the continuing awareness of surface as texture, a tradition reaching directly to us through Rodin and Brancusi.

The fact of the actual textural variety of surface application of colour, both in the application of pigments and finishes, and in the use of self-coloured material furthers this.

Surface as colour is an extension from the confines of the 'natural' state of a material, traditionally dominant, of the means by which the density and mass of a volume may be altered. Surface is the vocabulary, the means by which sculpture is 'read', and what takes place is a broadening, a reinvention of that vocabulary. The gamut of colour used in relation to shape is descriptive of ranges of mood and intensity, and in this respect bears much resemblance to the use of the term in musical definition.

What was impressive about Scott's work was the evident determination to develop further, whilst many of his contemporaries at the moment appear to have reached an impasse. The disquieting thing, on the other hand, was the air of flimsiness which all the pieces had. Anthony Caro's spideriness was here carried to extremes. One influence on Scott's work was evidently the late Matisse collages, such as *The Snail*, which is now in the Tate Gallery. But the insouciance of Matisse's handling of colour on a flat surface did not always translate happily into three dimensions.

Trireme 1968
Steel tube, acrylic sheet, painted. 66″ × 180″ × 156″

Jann Haworth

Robert Fraser Gallery *February*

Jann Haworth's exhibition of new works at the Robert Fraser Gallery in February temporarily snuffed the New Year rumours that one of our most dynamic young dealers was shutting up shop. Opening his gallery in 1962, Fraser promoted such Pop 'stars' as Richard Hamilton, Peter Blake and Eduardo Paolozzi, and his was the first London Gallery to show to the British public the work of Americans like Jim Dine and Claes Oldenberg, Larry Bell and several other Californian West Coast artists.

Hollywood-born Jann Haworth joined Fraser in 1966 with a one-man show which riveted attention. Her sewn and stuffed creations of, for example, the Movieland Cowboy, ritzy Mae West, a Dick Tracy strip-cartoon, constituted a kind of 'soft' Pop – Southern-style. In shiny silks and satins the figures breathed an irrepressible fun and glamour, now quite removed from her latest work. The extraordinary technique of sewing and stitching remains, but the glossiness has vanished and in its place is nostalgia for a Victorian past: stuffy, faded and genteel. In set pieces cluttered with bric-à-brac, the figures stare blankly into the middle-distance like people frozen in daydreams. Three Teddybears, each wearing the face of John Betjeman, sit at a picnic spread on the gallery floor complete with gingham table-cloth and bottle of mead. The spectator becomes Alice in a world not quite forgotten and in fact, though piecemeal, still with us. Pocketed between skyscrapers and moonshots, Miss Haworth discovers lavender and lace; between commuters and psychedelia, housemaids and aspidistras.

The strange thing is that she manages to turn this apparently old-fashioned and even sentimental material into impeccably up-to-date works of art. The meticulous craftsmanship has, perhaps, a distancing effect on the subject-matter she chooses. Whatever she depicts by this laborious means is, so to speak, frozen by the technique employed, coolly offered for our inspection, and at the same time preserved from the possibility of change. The fact that, in a world where everyone is looking for short-cuts, Jann Haworth takes the long way round, tells us a good deal about her attitudes. An artist who puts so much sheer effort into what she does is offering us a kind of guarantee: she is really committed to her subjects. No one who has seen Miss Haworth's work could doubt it.

Installation shot of exhibition, showing Old Man and Old Woman

Photograph: Iain Macmillan

David Hockney

Whitworth Art Gallery, Manchester

February - March

It was enterprising of the Whitworth Art Gallery to stage this retrospective, and surprising that such a show had not previously been seen in London.

Hockney is the *wunderkind* of contemporary British painting, but has pursued what seems like an erratic course – from the *faux-naif* style of his work in the early sixties to the chilly realism of his most recent painting. The Whitworth show managed to illustrate the full range, but not without encountering certain difficulties. It is revealing that Hockney, who is only thirty-three years old, should be so successful as an artist that many of his works are unavailable for an exhibition of this kind, mainly because they have found their way into major collections in the United States. Therefore the Whitworth exhibition was not always able to show

Hockney at the absolute top of his form.

The story it told was that of an artist who was chiefly interested in ideas about illusion. The difference between the early paintings and the later ones was that between an object glimpsed out of the corner of one's eye, and an object which one has the leisure to stare at intently and for some minutes. Unfortunately, Hockney's increased ability to confront the world, which in his case means also the ability to confront the quirks in his own personality (he has always been an autobiographical artist), has been accompanied by a loss of warmth and charm, which if perhaps inevitable seems also regrettable. The retrospective devoted to him did nothing to answer the question of what his eventual stature will be in the history of British art, though it did successfully explain some of the reasons for his success with collectors and with the public. These were paintings which combined wit and vulnerability in equal proportions, and such qualities can make either for immortality or ephemerality. At any rate, Hockney's uniqueness was confirmed.

Peter Getting Out of Nick's Pool 1967
Acrylic on canvas
84″ × 84″
Collection: Walker Art Gallery, Liverpool

Gillian Ayres

Kasmin Gallery *January - February*

Unlike most of the established British artists who
showed this year, Gillian Ayres had the courage to make
the big break in style. Unfortunately, courage alone is
not enough to produce a good exhibition. Looking for
a new style, Miss Ayres produced what seemed like a
mere pastiche of the American, Larry Poons, with large
pictures in which dots and spots of colour were evenly
but irregularly distributed over a ground. The
difficulty which British artists have in breaking free
from American ideas was never more convincingly
demonstrated.

 The best thing about these works, derivative though
they seemed, was their confidence in handling scale.
The current fashion for very large pictures seems to put
women artists at a particular disadvantage.
(*See colour illustration page 26*)

Hide 1968
Acrylic paint on canvas 9′ × 9′ × 9″

Anne Norwich

Bear Lane Gallery, Oxford *March 1 - 22*

This show was slightly out of the mainstream, both in
style and in the gallery where it took place. Essentially,
what Anne Norwich tries to do is to combine ideas
taken from the tradition of free abstraction with
elements which are crisply outlined, and belong to the
quite different world of hard-edge. This conflict of
philosophies within the boundaries of the same canvas
often breeds work which has tension and toughness.
A strong point is the sonorous, often rather sombre
colour. The show made an instructive comparison with
the Helen Frankenthaler exhibition at the Whitechapel
Gallery (see p. 52), though the paintings were mostly in
a minor key. Certainly, the Englishwoman and the
American have an area of sensibility in common.

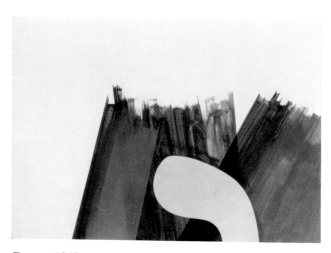

Grass 1968
Acrylic on canvas $21\frac{3}{4}″ × 31\frac{3}{4}″$

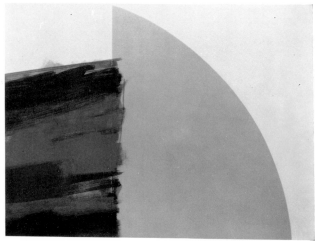

Half Moon 1968
Acrylic on canvas 22″ × 30″

Jeremy Moon

Rowan Gallery *March - April*

Moon is already well known for his experiments with shaped canvases, and his 1969 exhibition carried these experiments a stage further. The main idea was a canvas patterned in squares which looked as if a rectangle had been carefully folded up to produce a kite-like shape, disturbing the alignment of the squares in the process. The pictorial argument was therefore one about illusion and reality – the kind of argument, in fact, which tends to mark off British painters from their American rivals of the same generation, who are inclined to confine themselves to images where a strict frontality is maintained, with no suggestion that there could be any other way of looking at the material presented.

Moon's exhibition was therefore interesting not only for its own sake but for defining rather neatly the tone and the intentions of a certain variety of British art – the kind that comes closest to American post-painterly abstraction of the Noland-Stella brand, while still being recognisably different from it. American critics tend to criticise British painters who belong to this group not only for the ambiguity of their intentions, but also for a certain lightweight air, a hedonism which seems alien to the serious purposes of modern painting. Moon's canvases were light in two senses: not very weighty in pictorial content or complex in argument, they were at the same time elegant and decorative. The basic shape chosen by the artist acquired an attractive airiness thanks to the colours and shapes which he imposed on it, and seemed to soar across the wall like the kite it resembled.

Another point of interest about the show was the closeness in feeling between Moon's pictures and the sculpture which is currently being produced by British artists of his own generation. Here, too, one finds the cool exploration of formal problems, the interest in ambiguity, and a limitation which seems in one sense calculated, and in another sense the product of temperaments which are perhaps a little too cool, a little too detached. The dryness of the neo-classical painting and sculpture of eighteenth-century artists such as Flaxman and Stothard seems to reappear here in contemporary guise. *(See colour illustration page 73)*

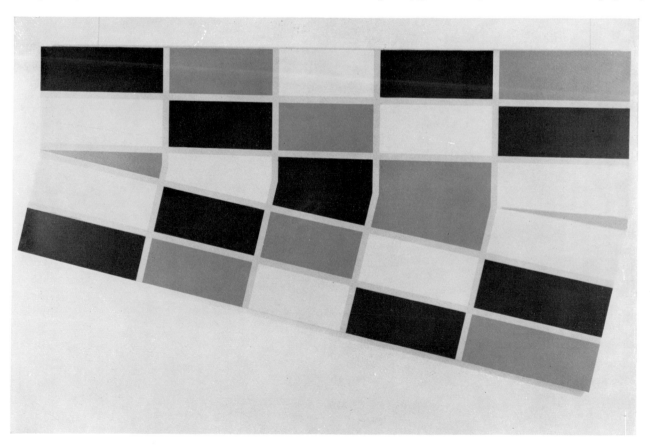

Apollo 1968
Acrylic on canvas 156″ × 83″

Egon Schiele 1890 - 1918

Marlborough Fine Art *February - March*

Egon Schiele has become something of a cult in the London art world. There is nothing too surprising about this, as the Marlborough's exhibition of drawings and watercolours showed.

Schiele had the great advantage of being *un peintre maudit*. But this would not in itself have been sufficient; there was also the case that tastes have begun to swing back towards what interested Schiele. Here is a draughtsman with a perversely decorative sense. These emaciated figures, which are thrown onto the paper at odd angles, display the artist's unfailing grasp of the correct balance of line and colour needed to fill out and animate the space at his disposal. At the same time, these compositions are very often deliberately imbued with a violent erotic charge. When Schiele draws a nude one can never forget its sexuality, and one cannot forget the sexuality of many of the clothed figures either. Schiele is too much obsessed with a narrow tract of human experience to be a really great artist, but whatever he touched he stamped with his own vision.

This vision we see in his drawings is one which we also recognise in the work of English contemporaries, such as David Hockney and Patrick Procktor in particular, though one notes that they prefer the cool, or the frivolous, to Schiele's acrid conception. Their detachment makes a strange contrast with the earlier artist's febrile intensity of feeling.
(*See colour illustration page 68*)

Reclining Woman — Dressed *c.* 1911
Pencil and watercolour $12\frac{1}{4}''\times17\frac{5}{8}''$

Charles Ginner 1878 - 1952

Piccadilly Gallery March - April

This exhibition of paintings by a founder member of the Camden Town Group, Charles Ginner, was one which gave nostalgic delight. Ginner, born and raised in France where his father was a practising Doctor, was aware of the new 'post-Impressionists' some time before Roger Fry introduced their work to London in the two exhibitions of 1910 and 1912.

Ginner came to London in 1910, and liked it enough to decide to stay. The methods of the post-Impressionists greatly influenced his manner of applying paint in large but meticulous dots of pure colour, but the style he developed was peculiarly his own. Clear, ordered, almost fastidious in its compression of detail, he lovingly recorded ordinary, everyday scenes, in accord with the Camden Town Group's philosophy of a new realistic approach to the urban and rural life of England in the years before the First World War.

Ginner drew and painted consistently throughout his life, serving as an official war artist in both World Wars – for which he was made a C.B.E. in 1950 – and never much altering his original vision of things.

His pictures were a recollection of childhood and a lost simplicity to older members of the public, and to the younger, perhaps, they brought a vague longing to 'have been there then'. They were also a reminder of the time when English art, although feeling slightly the waves of change emanating from Paris, still lacked its international character.

The Hillside 1913
Oil 27″ × 20″

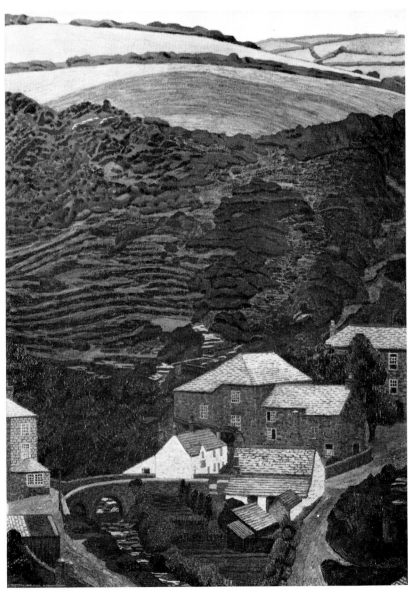

93

William Holman Hunt 1827 - 1910

Walker Art Gallery, Liverpool *March - April*

Victoria & Albert Museum *May - June*

This decade's upsurge of interest in things Victorian has prompted a serious reassessment of Victorian painting, which had previously been either forgotten or dismissed as over-worked and too literary. The Victorian painter who epitomises the moralistic tone which was once considered so nauseous is the Pre-Raphaelite, William Holman Hunt.

Hunt was the most resolute and single-minded member of the Brotherhood. Deeply religious and inclined to self-righteousness, he considered that art should convey a message: that it should lay down rules of Truth, Beauty and Justice. But his search for realistic perfection was too feverish, his symbolism too heavy-handed. Even to the critics of his own period, Millais's lighter, more technically fluent touch appeared more acceptable; and Millais, in consequence, always received

more attention than Hunt – even though it was Hunt who laid the foundations of Pre-Raphaelitism.

This attitude towards the two painters still prevails; Hunt's work had to wait in line for reappraisal behind Millais's paintings, which were given a grand airing at the Royal Academy in 1967. But in 1969 it was Hunt's turn, with a major exhibition organised by the Walker Art Gallery, Liverpool, which later came to the Victoria and Albert Museum. The show was extremely well received by the London critics who, although conceding Millais's artistic superiority, praised Hunt's passion and total commitment to his work, and his daring use of colour.

David Thompson discussing, in the *Sunday Times Colour Magazine*, the once-derided *Scapegoat* said: It doesn't matter much to us if we know the 'story' or not. The picture succeeds, as it were, by default. Many people would still call it downright bad, if not faintly ridiculous. But it remains obstinately memorable, by its very oddness, its obsessiveness, its intensity . . . Hunt is one of the artists whom the Surrealists have always claimed as a proto-Surrealist, which is an ironic justification of his attempt to portray the otherworldly

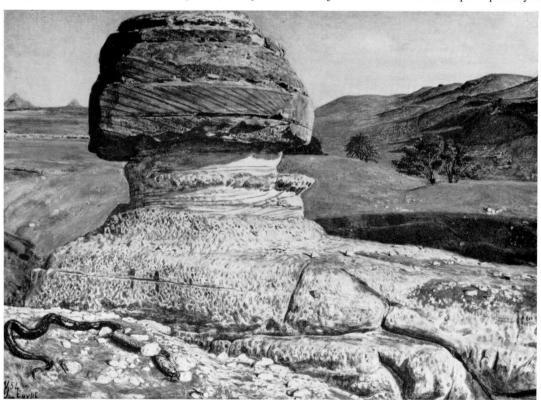

The Sphinx, Gizeh, looking
towards the Pyramids of Sakhara 1854
Watercolour 10″ × 14″
Collection: Harris Museum and Art Gallery, Preston

in factual terms. The *Scapegoat* is a plausible enough candidate for a dream-picture. But one can see that it is not the strangeness of the image alone which makes it so as soon as one compares it with the smaller version of the subject which he painted at the same time. There the colour is even more intense, the scene even more dramatic. But it conveys nothing of the final version's horror, the effect of each crack in the salt, each hair of the goat, staring back at you in baleful impassivity. For all its exotic setting the picture has something of that frightening quality of the banal which the Surrealists know exactly how to recognise.

One wonders what Hunt – always acutely concerned about critical opinion – would have thought of 1969's reaction to his work. He would doubtless be convinced that his 'message' had at last got through. But is his moral statement so very different from that of the 'Earth Artists' at the I. C. A.'s 'When Attitudes Become Form' exhibition later in the year? They too, as Hunt did, went off into the desert, made a sweeping heroic statement, and came back bearing photographic evidence of their gesture. *Plus que ça change, plus que c'est le même Kodak!*

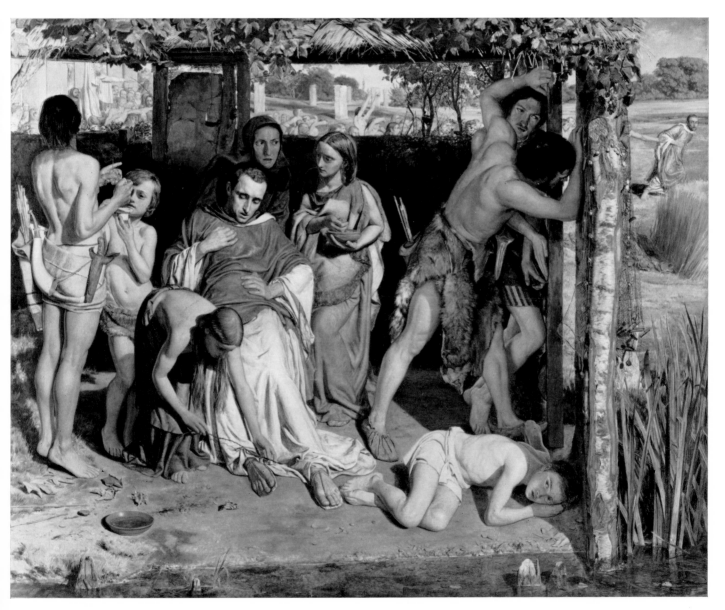

A Converted British Family Sheltering a Christian
Priest from the Persecution of the Druids 1850
Oil on canvas $43\frac{1}{2}'' \times 52\frac{1}{2}''$
Collection: Ashmolean Museum, Oxford

Howard Hodgkin

Kasmin Gallery March - April

Howard Hodgkin's exhibition at the Kasmin Gallery confirmed a growing reputation, while being more or less the mixture as before. Thirty-seven years old, Hodgkin is an unclassifiable painter with very few apparent links with other British painters of the same age; his art is figurative, but it is an extremely hermetic kind of figuration. Reality is coded, not according to any system, but according to the dictates of feeling. The pictures are painted and re-painted, at each stage moving farther from whatever it was which originally inspired them. Particularly significant is Hodgkin's habit of presenting a fragment of imagery on a canvas where most of the area has been censored or blotted out.

Though his work shows few parallels with that of his contemporaries, it is possible to suggest at least some valid comparisons. He is clearly very much interested by the Fauves, and especially by Matisse's habit of using pattern on pattern in light-filled interiors. He is also fascinated by the pictorial effects to be found in Indian miniatures – he is an expert on these and a collector. His work has a density of pictorial reference which gives it a sophistication far beyond that to be found in the general run of current work.

One extremely interesting thing about the show was the fact that it was one of the few by a painter of Hodgkin's generation which relied on the single work as a unit of perception. So many other exhibitions, and particularly in this gallery, have become environmental shows, where it is the effect of a series of pictures which counts, rather than that of one picture on its own. It might possibly be argued that Hodgkin's pictures don't hang particularly well together, as each is so enclosed and so insistent. The eager market for them, nevertheless, argues that many private collectors are still looking for paintings which will withstand prolonged contemplation. (*See colour illustration page 29*)

Indian Subject (Blue and White) 1968–9
Oil on wood 48″ × 54½″

Victor Pasmore

Marlborough New London March - April

Victor Pasmore is one of the artists who have been most consistently supported by the prestigious Marlborough Galleries, and this support is to their credit as Pasmore's development has not always been an easy one for the public to follow. His abandonment of his early figurative style is still nostalgically regretted by important collectors, as the prices which his early works fetch when they appear at auction go to prove. This year's exhibition entitled 'The Space Within' showed that Pasmore has now very thoroughly established himself in his later manner. The process which goes into making the current work is thus described by the artist himself: If we take a sheet of paper and scribble on it vigorously we become involved in the process of bringing into being something concrete and visible which was not there before. The shape and quality of what we produce is the outcome of forces both objective and subjective: a particular tool, a rotary action and a human impulse. The more we concentrate on this operation the more we are drawn into it both emotionally and intellectually. But as the line develops organically, in accordance with the process of scribbling we find ourselves directing its course towards a particular but unknown end; until finally an image appears which surprises us by its familiarity and touches us as if awakening forgotten memories buried long ago. We have witnessed not only an evolution, but also a metamorphosis.

The word 'metamorphosis' seems to be the clue to

what Pasmore is trying to do, even in the most deliberate of his constructions. The works in the show often had the word 'development' somewhere in their titles, and these were forms which seemed to be evolving and varying in a musical way.

Pasmore belongs to the tradition which encompasses also the work of Ben Nicholson, and, though superficially their work is not much alike, Pasmore and Nicholson have a good deal in common. They are both examples of a certain kind of rather puritan English sensibility: at their worst both of them produce pictures which seem pallid and bloodless. At other times a superb balancing act takes place – the artist reconciles the conflicting claims of the intellect and the senses to produce work which is fruitful in its austerity.
(*See colour illustration page 76*)

Colour Construction in five colours 1968
Oil on board 48″ × 48″

Brauer

Marlborough New London *April - May*

Brauer is the leading member of the Vienna School of Phantastic Realism and has been frequently exhibited since the mid-fifties on the Continent, and particularly in Austria and Germany. His exhibition was, nevertheless, something unexpected in the general context of London art shows, though it might be argued that his work has a little in common with some of the paintings selected later in the year by Mario Amaya for the 'Young & Fantastic' show at the I. C. A.

Brauer is an unashamedly literary artist, as appears from the following statement which was printed in the Marlborough catalogue:

In my paintings I had for years used the human figure just as I would beetles, houses or glow-worms, or the shimmering light in a landscape. But after the face and body of my wife were constantly in my sight, I began to paint huge figures that dominated the compositions. The human being would grow into a tower: the round head with its orifices, the repeating pattern of the ribs, the grooved folds in clothing, these formed the basic units of my edifices, flying objects and formations. The tower became humanised again. A window without eyebrows is an empty hole, and it is a disgrace to be seen framed in one. A gateway without lips or cheeks is a gateway to Hell, and one should beware of passing through it.

If this statement suggests that Brauer has something in common with Bosch and Brueghel, but especially with Bosch, the impression is perfectly correct. In fact, one of the things which the show demonstrated was the difficulty which modern artists have in discovering a completely fresh way of looking at even the most personal material. Brauer's meticulously painted works are reminiscent in more than one detail of the masters whom I have just named: here, for example, are the landscapes with abrupt mountains and distant perspectives which are familiar from the masters of the fifteenth and sixteenth centuries. Here too, are the strange conflations of forms and the sudden shifts in scale which distinguish Bosch in particular. Granted these heavy debts, the show was by no means negligible. The fantasy had benefited from the artist's knowledge both of the Surrealists and of the works of his fellow Viennese, Sigmund Freud. The glowing colour and the refined craftsmanship to be seen in every work were eloquent of something, though on occasion it was difficult to be quite sure of what.

In any case, Brauer's work served as a reminder of the fascination of the kind of painting which does not offer itself entire to a single glance. Repeated inspection continues to reveal new details in almost every picture – and this is a satisfaction the public is still loth to surrender.

(See colour illustration page 35)

Flying Jacket 1967
Etching $7\frac{1}{8}'' \times 9\frac{3}{4}''$
Marlborough Fine Art

Arthur Boyd

Richard Demarco Gallery, Edinburgh

April - May

This was the first and more important of the two exhibitions by the prolific Australian figurative painter Arthur Boyd to be held in Britain during the year.

Boyd is an artist who divides the critics – some find him sentimental, some a master of fantasy. His long-time admirer T. G. Rosenthal very justly remarked in his catalogue introduction to the Demarco show that 'the world which Boyd creates in his art is, very obviously, an inseparable blend of fantasy and reality, but his starting point for the reality is not very real in the first place.' Boyd is therefore by nature and intention extravagant, and the large and lavish show in Edinburgh was very successful in pleading the case for the sumptuousness of his colours, and the warm eroticism of many of his designs. At the same time, it could not avoid revealing certain persistent weaknesses – in particular a weakness of drawing which seems to hobble the artist at crucial moments. Visionary artists, as it happens, are usually forgiven such weaknesses by their admirers. On another level, the Boyd exhibition was important both as a large-scale one-man show mounted outside London, and as an affirmation of the validity of a relatively traditional kind of art in an art world which currently seems intent on avoiding traditional formats at almost any cost.
(*See colour illustration page 34*)

Double Figure with Shark's Head and Horns
Etching and aquatint $13\frac{3}{4}'' \times 15\frac{3}{4}''$

Richard Hamilton

Robert Fraser Gallery *April*

Richard Hamilton's exhibition at the Robert Fraser Gallery proved the continuing artistic vitality of a painter who is probably the most important artist to come out of London since Francis Bacon, and who, unlike other British artists, could now be resting on his reputation.

For example, it was interesting to witness the awe with which spectators at the Hayward's Pop Art show later in the year approached Hamilton's famous collage, *Just what is it that makes today's homes so different, so appealing?* Done in 1956, this first 'Pop' picture was treated with the same wide-eyed reverence an average crowd of American tourists might give to the *Mona Lisa* in the Louvre.

Hamilton is, unquestionably, one of the great figures in the British art of our time and his influence, both personally and through his work, on younger painters has been profound. In his pictures he has recreated, with precision and wry humour, the imagery of the mass-media: the glamour of pin-ups and public figures, the all pervasive (and persuasive) advertising we meet with at every turn, in our homes, on television, in newspapers, on packaged goods, hoardings, etc. His has been an identification of the Western world's preoccupation with, for instance, motor-cars, chromium-plated household gadgets, fashion and furnishings, movie queens and pop singers.

He once said that he produces 'paintings of and about our society', and the Fraser exhibition aptly illustrates this. On show were paintings of beach scenes: repeated views of anonymous figures sunning and besporting themselves, done deliberately and accurately in the artificial style of coloured holiday postcards to be found on sale at every beachside shop. These works cast a cool glance at a traditional human activity, looked at through the zoom lens of a camera, snapped, frozen,

blown up and broken into photographic dots. The result is pictures of stunning beauty.

These beachscapes were directly opposed in feeling to a series of paintings based on a press photograph of Hamilton's dealer, Robert Fraser, and of the pop singer, Mick Jagger, taken at the time of their arrest on a drugs charge. Both have a hand raised, looking as if to shield their faces from the camera's intrusion, but this interpretation denies the temperament of the two 'fugitives', who are in fact waving their handcuffs to the crowd and grinning broadly. The two figures are painted again and again in varying shades of harsh colour, which gives them the look of Technicolor film stills. The point Hamilton is hammering here so relentlessly, is how a photograph can lie – especially a newspaper photograph. One is left with a feeling of unease and the thought that nothing is to be believed.

Looking back, Hamilton's was the most impressive and stimulating one-man show of the year.
(*See colour illustration page 36, below*)

Richard Hamilton
Bathers I 1967
Oil on photograph on canvas
with collage 33″ × 46″

Patrick Procktor

Redfern Gallery *April - May*

Procktor's art is hedonistic, and this was his most hedonistic show to date. It was a celebration of a carefully created private world – luxurious interiors inhabited by beautiful boys and decorated with opulent vases of flowers. In an age fascinated by aesthetic theory, Procktor blithely disregards intellectual demands and contents himself with creating an art where the desire to ravish the senses is allowed to overrule pictorial inconsistency. For these were inconsistent works – often two or more styles seemed to co-exist uneasily in the same picture; often, too, the results were emotionally ambiguous. It is impossible to tell, for instance, just how interested Procktor is in what he happens to be painting. One gets the sense that he condescends to his subject matter. In the watercolours the technique is consciously, even insistently, refined – finicking, almost. In the larger paintings one notices how the composition dissolves into a multitude of details and how impossible it is to focus on it as a whole.

David Hockney and Patrick Procktor are often thought of as equals and rivals. Certainly, they belong to the same generation and use much the same range of subject matter. It is interesting to see, however, how very different their recent paintings are from one another. Hockney's bleak interiors with their monolithic figures, their lurking sense of irony, have little to do with the fragmented, prismatic, and – in the end – morally neutral world which Procktor presents. The real

importance of Procktor's paintings, prints and watercolours is, perhaps, that they encapsulate a certain view of fashionable London. It is no longer smart for artists to be smart; Procktor flies in the face of this convention. It is surprising how often he gets away with the act of defiance.

(*See colour illustration page 37*)

Patrick Procktor
See you Feb 14 1969 Watercolour 30″ × 22″

E. Vuillard 1868 - 1940

Arthur Tooth & Sons *April - May*

Vuillard does not have quite Bonnard's strength or inventiveness, as could be seen by comparing this exhibition with the show devoted to works by Bonnard which followed it at the same gallery a little later. Nevertheless, this was a distinguished exhibition.

The way in which Vuillard uses pattern and form in counterpoint to one another (to the point where one sometimes seems to contradict the other) still seems strikingly original. Younger British artists as different from one another as Howard Hodgkin and Patrick Procktor could still be brought into a relationship by considering their debt to Vuillard, as demonstrated by their own tendency to make use of such devices. Indeed, the whole French *intimiste* tradition seems to be continuing quite successfully in British art while it has petered out elsewhere, and 'Britishness' can be defined by looking for the traces of the impact made by Vuillard and Bonnard in particular.

(*See colour illustration page 67*)

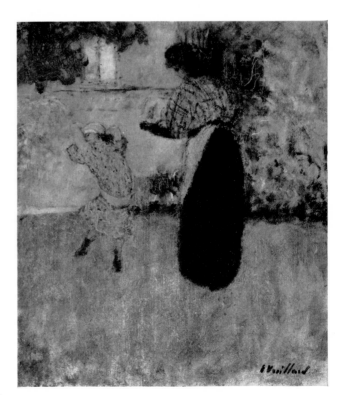

La Danse
Oil on paper 14″ × 12½″

Morris Louis 1912 - 1962

Waddington Galleries *April - May*

Impressive single paintings by Morris Louis have appeared in mixed exhibitions in London, but opportunities to see a whole group come seldom. The Waddington Galleries exhibition, drawn from the holdings of the artist's estate, included works of three different, but typical, kinds – the sombre veil paintings of the late fifties; the unfurleds of *circa* 1961, and the tall, thin, striped paintings of 1960 – 2. Of all artists, Louis is one of those who responds least well to critical verbalisation. These pictures were important because they were the source material for so much else which was on view in London during the year. In another sense, however, they were already Old Masters – a part of the history of modern painting, an episode which was already closed and done with. The terrifying speed with which modern painting ossifies has seldom been more forcefully demonstrated.

(*See colour illustrations pages 32 and 33*)

William Gear, paintings 1948 - 1968*

Arts Council of Northern Ireland Gallery, Belfast *April*

Brooke Park Gallery, Londonderry *May*

Scottish Arts Council Gallery, Glasgow *July*

Before being shown in Scotland, the William Gear retrospective had been on view in Belfast and Londonderry. It provided a welcome opportunity to reassess the work of an established painter now in mid-career.

As Philip Barlow pointed out in his catalogue introduction, Gear was, in the late forties and early fifties, 'among the few nationally known "abstract" painters'. The fact that abstraction is no longer an issue must necessarily affect our reaction to his work.

In fact, Gear is not purely abstract. As the titles of many of his paintings make clear, he is an interpreter of landscape. The patterns he uses derive from the forms of tree-trunks and hedgerows. He thus extends the neo-romantic tradition. One is far more aware of the romantic mood than the lack of specific representation, and Gear seems more closely linked to the conservative British tradition of landscape-painting than he did in the days when he first established himself.

The good things about his work are precisely those elements which look back – to the Samuel Palmer of the Shoreham period, for instance. The besetting fault is that the 'abstract' patterns often seem merely mechanical. One can see from Gear's work how very slow British art was, even after the war, in coming to terms with modernism and its demands. The Vorticists of 1913 – 15 (the subject of a retrospective at the d'Offay Couper Gallery in London in November-December, see page 63) were more radical than Gear has ever been. Comparison with the Vorticists was also revealing in another way. Gear makes use, just as they did, of the zig-zag line. But while theirs are full of energy, and even of violence, his shapes are apt to seem merely decorative. In their work we find a feeling of excitement, danger, discovery, but in Gear's work there is only a quiet dialogue with an existing tradition.

*Presented jointly by the Arts Council of Northern Ireland and the Scottish Arts Council.

Diamond Structure 1968
48″ × 36″
Scottish Arts Council Gallery, Glasgow

Man Ray

Hanover Gallery *April - May*

The Hanover Gallery have already staged one exhibition of Man Ray's work, mostly consisting of some of his more famous Dada objects in new editions. This second show contained paintings and sculpture of a more recent period, most of them, in fact, dating from the 1940s and '50s.

Man Ray's importance as a pioneer photographer and Surrealist innovator is not, of course, to be challenged, but this exhibition did raise the question of whether his later work is to be taken at all seriously. The exhibition teemed with reminiscences of artists as apparently opposed to one another as Giorgio di Chirico, Hans Arp, Picasso, Picabia and Kandinsky, and the effect was largely that of an exhumation which had been scarcely worth the trouble. One thing which the show tended to emphasise was the fact that there are now at least two different kinds of modern art available to the British public: the 'classic modern', and the 'contemporary'. When the classic modern offers as feeble a challenge as it did here, it does not seem surprising that young artists in Britain are more and more inclined to reject the international tradition.

L'Homme Infini 1942
72″ × 50″

Les Balayeurs 1959
80″ × 72″

Le 'P' 1953
$35\frac{1}{2}$″ × $58\frac{1}{4}$″

Peter Joseph

Lisson Gallery *April - May*

The Lisson Gallery has the reputation of being one of the most enterprising small galleries in London, with a policy which is both adventurous and well-defined. Peter Joseph is an artist whose work is somehow very typical of the Lisson – severely abstract, and related to experiments in kinetic art. He first made his reputation at the now-defunct Signals Gallery with an ambitious work, 32 feet long, called *Colour Continuum* – a procession of broad vertical bands of colour. The critic Paul Overy subsequently called this 'one of the most exhilarating and exciting works produced by a British artist in the last few years'.

Joseph's 1969 one-man show was a summary of the experiments he had made since the *Colour Continuum* was produced. He has worked with canvases divided into four equal rectangular areas, each painted a different colour; with striped canvases; and finally with triangular canvases painted a uniform hue. The rectangles and the stripes illustrated the difficulties which confront a young painter who narrows his formal vocabulary to such a drastic extent. As Timothy Drever remarked in the catalogue introduction: 'no charm of incident or accident clouds the issue of the few decisions informing each work, and so each decision is critical'. Thus, the stripe format inevitably recalled Kenneth Noland's work (a universal influence in Britain at the moment), though close examination revealed subtle differences – Joseph gently bows the line dividing his stripes, and this in turn generates a kinetic energy which is far from Noland's intentions.

The most striking exhibits, however, were the two triangular canvases, one yellow, one green. The critic of the *Financial Times* well-described the effect of these when he said:

The dimensions and positioning seem to relate closely to the human body: the distance from finger tip to finger tip when the arms are outstretched, one's height and line of vision and the contact with the ground through one's feet. Like [David] Smith's sculpture, the spectator's presence adds a new dimension to the work and all the other dimensions immediately relate to this.

As this description suggests, Joseph seemed to be moving towards the idea of art-works which were not necessarily complete in themselves, but which acted as catalysts for a change in the surrounding environment. Later in the year (see p. 108) Joseph was to show seven-foot discs of fibreglass, painted a pure yellow, meant to be placed here and there in a landscape.

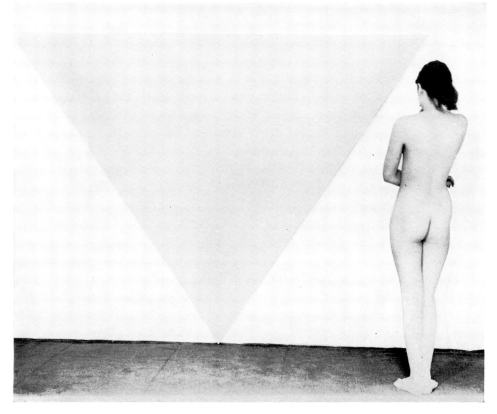

Yellow Triangle 1969
Acrylic on canvas
7′ 6″ × 8′ 6″ × 7′ 6″
Collection: Arts Council
of Great Britain

Icons

Temple Gallery *May - July*

Our excuse for including this apparently specialist exhibition in a volume which is largely devoted to modern art activity must be that it so neatly serves to illustrate the change in sensibility which has taken place in London in recent years. It is significant that no English public collection has a good group of icons on view at the present moment; it is equally significant that a private gallery was able to mount this show of which almost any museum might have been proud. The icons on view ranged from a Crusader icon of the thirteenth century to fine examples from the sixteenth and seventeenth. It was thus possible to gain at least a sketchy idea of the development of this form of art in both Greece and Russia over a period of about four centuries, the richest in the history of the icon.

To the spectator habituated to modern art, the thing which was immediately striking was the attitude of the icon painters towards colour. Their compositions, like those of the artists currently most in vogue, were constructed by means of colour, and it was the subtle brilliance of the hues which animated designs which were often thoroughly conventional, accepted formulae handed down by the makers of icons from one generation to the other. If one doubts the nature and purposes of much modern art, its ability to reanimate and comment upon the work of the past must necessarily seem reassuring. At the same time, it is clear that exhibitions such as the one at the Temple Gallery have a real impact on contemporary artists themselves. (*See colour illustration page 40*)

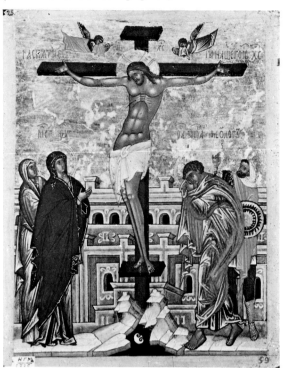

Double-sided icon, Novgorod school. The Virgin and Child, and The Old Testament Trinity (illustrated) 15th century
$9\frac{1}{2}'' \times 8\frac{3}{4}''$

Oskar Kokoschka

Marlborough Fine Art *March - May*

In recent years, Oskar Kokoschka has been a very active maker of prints, and though this show contained other material, its real purpose was to launch a new portfolio of lithographs which illustrated the biblical story of Saul and David.

Kokoschka's expressionism has long ago been tempered into a sort of neo-baroque style, in which the artist paraphrases the kind of thing which decorators such as Pietro da Cortona did in the seventeenth century. He shares with the masters of the baroque an unfailing decorative fluency, but it is surprising how seldom these images are truly memorable. There is a restlessness about Kokoschka's work in his old age, which wearies as much as his continuing energy impresses. In the end, one was more thankful for the peripheral items in the Marlborough exhibition than for the suite of prints which formed its centrepiece. When Kokoschka paints a watercolour of flowers, for instance, one is aware of his wonderfully undimmed and open sensibility. The blooms, which appear to be tossed down onto the paper with the utmost carelessness, have a fresh and convincing quality which the more literary work lacks, at least for these two commentators.

His Old Testament illustrations, however, don't seem the product of a fresh response to the text; we get the expected incidents and the expected emotions, served up in an equally familiar sauce: Kokoschka's style. The excuse for re-illustrating a great text ought to be more apparent than it was here.
(*See colour illustration page 30*)

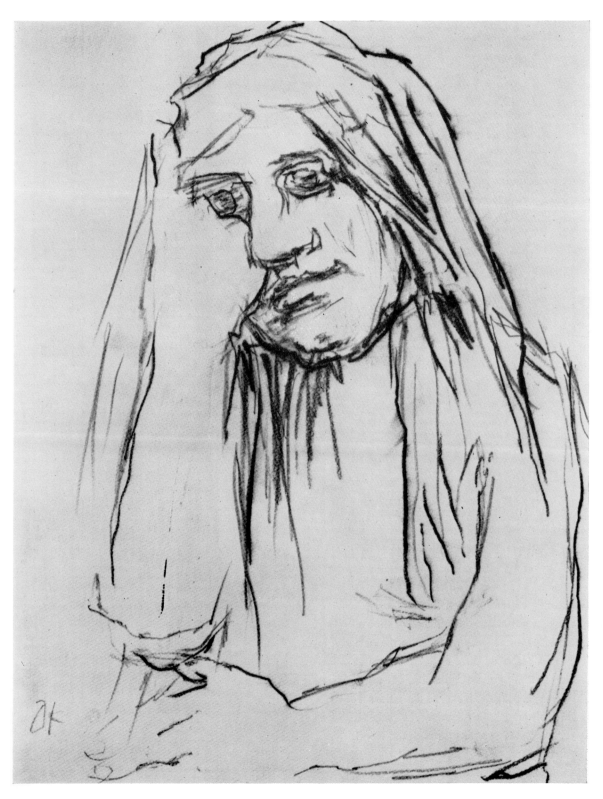

Abigail from 'Saul and David' suite 1969
Lithograph 17″ × 13″

Ian Hamilton Finlay

'Carnegie Festival of Music and the Arts'

Pittencrieff Park, Dunfermline *April*

Ian Hamilton Finlay has had the misfortune to be
classified as a poet. In fact, his artistic activity now
embraces poetry, sculpture and landscape. His own
garden at Stonypath, Dunsyre, Lanark, has any number
of delightful experiments in which nature is made to
interact with the formality of words. This open-air
exhibition repeated the experiments he has already made
in a larger and more spacious landscape. Particularly
successful was the attempt to articulate the natural
scene, and give it a new meaning by means of objects
placed within it. In this sense, what Hamilton Finlay
was doing here was very much like the kind of thing
which Peter Joseph tried to do at Kenwood in May,
and illustrates the way in which the notion of 'the
garden landscape', as our ancestors would have
understood it, has been brought into contact with the
modern concept of 'the environment'.

Ian Hamilton Finlay
Kirkcaldy fishing-boat letters, and signpost poem
Photograph: Ronald Gunn

Timothy Drever and Peter Joseph

at Kenwood *May - June*

These two environmental art projects are difficult to
judge, partly because of the vandalism which dogged so
many open air projects during the year under review,
and partly because of bad weather on the day we chose
to inspect them. Drever's project consisted of about a
hundred flat geometrical shapes of different kinds,
strewn on a close-clipped lawn. The visitor was invited
to re-arrange these to suit himself. Peter Joseph showed
three fibreglass discs, painted yellow, placed in the park
landscape. The artist described them as 'unambiguous
signals, conveying nothing but their position, but setting
up cross-references spanning the scene, as the visitor
views two or more of them from a distance, or comes
across one unexpectedly as he walks through the woods'.
He added: 'Thus the paradox of landscape and
abstraction is momentarily resolved; the work of art is
re-absorbed in its origins.'

 Taking up the theme, Guy Brett commented on the
two projects in *The Times*:

Peter Joseph Yellow Disc 1969
Plywood and acrylic 7′ × 7′ × 1″
Courtesy: Lisson Gallery

Are they paintings, or sculpture, or landscape gardening? I think their interest and importance is that they are partly all three . . . The presence of Peter Joseph's discs, though basic and unremarkable in themselves, draws the entire visible landscape together . . . Being a kind of constant bright visual magnet in the mobile variety of the landscape they draw the eye across the intervening space in a flash, giving you the sensation of knowing it intimately.

It is, of course, arguable that the first 'environments' in something approaching the modern sense were the English gardens of the eighteenth century, and still more the parks laid out by Capability Brown. The Kenwood experiment brought together the ideas of two centuries, the eighteenth and the twentieth, and showed that the English sensibility had altered little in the interim.

In fact, there is even a parallel on the plane of aesthetic theory. The object of the great English garden architects was to create a 'tone of feeling' in the spectator, as he wandered through a controlled environment. Certain points of interest – usually a temple, or a folly, or a grotto – helped to keep the wanderer and the landscape in tune with one another. In a more etherial, less literary way, this was what Drever and Joseph were up to too.

'New Sculpture 1969'

Stevenage New Town Shopping Centre
May - June

The Arts Council commissioned large-scale work from six of the young sculptors who work at Stockwell Depot (see p. 150 for our comments on the highly successful exhibition staged at Stockwell later in the year). The idea was to show these works first at Stevenage New Town, then later at Wollaston and Newcastle. Unfortunately, there was so much vandalism during the first few days of the exhibition at Stevenage that some of the sculptures were hastily removed from view and hidden in the nearby art college.

The local newspaper, the *Stevenage News* (20th May), adroitly trod the line between philistinism and commitment. A local resident was quoted as saying:

I think it's a waste of public money. It's absolutely flaming nonsense. It's what you'd expect a child of ten to do with a Meccano set . . . We pay out money on this when there are places like Clare Hall Hospital in South Mimms which was a refugee camp and is still used as a chest hospital.

Timothy Drever Four Colour Theorem 1969
Painted plywood
Courtesy: Lisson Gallery

Roger Fagin Untitled Chain Piece 1969
Railway sleepers and painted chains
approx. 60′ long × 20′ wide × 5′ high

But the reporter who wrote the story admitted, in his concluding paragraph, that 'the *Stevenage News* started thinking. And has been thinking ever since'.

Despite the damage, some of which was perhaps simply due to a too-enthusiastic response to the sculptors' wish for spectators to get involved with their work, the Stevenage show was a sign of the times. Having won the struggle for official recognition, modern art in Britain is beginning to come to grips with a much bigger challenge: the mass audience which doesn't necessarily care about art at all.

It is doing this in a world where the monument, which stands high on its pedestal, gesturing at the sky, seems both irrelevant and ridiculous. Art is going to have to put itself far more at risk, and not merely in the physical sense, in order to find a place in the future.

Gerald Hemsworth Untitled Stevenage 1969
Painted wood basic module approx 5′ square × 5′ high
Photograph: Margaret Murray

Keith Grant

Aldeburgh Festival *June*

Keith Grant's was perhaps the most ambitious of the open-air constructions put on view during 1969. The painted disc which formed the heart of the structure was a representation of the North of Norway, seen from the air. Across this were mounted twenty-four stainless steel mirrors 'each representing hourly points of the sun during the arctic summer day'. The mirrors were of different depths, intended to represent the rise and setting of the sun, and the disc itself was set back at an angle of $23\frac{1}{2}$ degrees – the angle of the axis of the earth.

The whole construction was designed to move clockwise on a turntable, mirrors and disc having independent motion. The mirrors broke up the painting on the disc into kaleidoscopic images according to optical laws. The whole work was contained within a cover derived from a solid geometrical figure which mathematicians label by the splendid word rhombicubeoctahedron. The artist says: 'I first noticed this figure in a portrait of the celebrated Renaissance mathematician Luca Pacioli, thought to be the work of Jacopo de' Barberi'. Despite, or because of, this elaborate programme, the construction had an austere beauty which went well with the bold shapes of the Maltings Concert Hall, which was unfortunately severely damaged by fire just as the Festival itself was about to begin.

Snape—Kinetic construction

110

William Tucker

Kasmin Gallery *May*

William Tucker, currently Gregory Fellow in Sculpture at Leeds University, is one of the best-known of younger British sculptors. This show, his most reductionist to date, was cooingly received by the reviewers. It consisted of four large sculptures; the basic element in each was a long cylinder, with two shorter cylinders crossing it at each end. These were arranged in twos, and the cut-off ends of the cylinders were coloured (blue, green, yellow or ochre); the cylinders themselves were white. John Russell commented enthusiastically:

The show . . . forms itself into a metaphor for the possibilities of playful association. The elements . . . pair off in different ways: sometimes performing a knee-locked dance, sometimes tilted high in the air, snapshotted half-way through a manoeuvre of their own invention . . . this show had a marine freshness: the gallery looks more than ever like the most beautiful room in London.

After reading this lively description, it was a disappointment to find the show so dull. For us, Tucker's less was less – not more. But clearly, our colleagues did not agree.

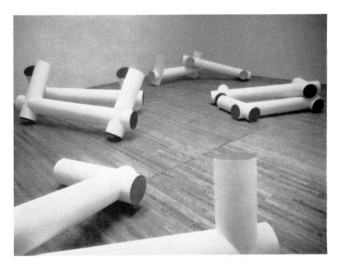

Gallery Installation shot of the William Tucker exhibition at the Kasmin Gallery

William Crozier and Barry Martin

Compass Gallery, Glasgow *May - June*

The re-opening of the enterprising little Compass Gallery gave Glasgow another much needed exhibition space for contemporary art. Perhaps the most interesting show in this year's programme was that devoted to etchings and drawings by William Crozier, and kinetic sculpture and paintings by Barry Martin. Martin's work has still not had a full scale London show, though it has been seen in various group exhibitions, including the 'Young Contemporaries' of 1966, and Martin's display at the Pavilions in the Parks experiment in Chelsea in 1968, was perhaps the most wholly successful use to be made of the space provided. The courage of the Compass Gallery in showing a young and gifted, but relatively unestablished and indeed unclassifiable, artist of this kind, encourages one to hope for good things in the future.

There is certainly a need for enterprise of this kind in the great cities of Britain. The Arts Council ought not to be the only source of modern art in a place such as Glasgow. The Compass Gallery represents a healthy degree of local involvement.

Barry Martin Inter 1968
Metal and light

'Six Swedes—
Contemporary Swedish Art'

Camden Arts Centre May - June

Contemporary Swedish art has tended to be written off in both England and America as being a trendy imitation of things which were originally created elsewhere. It is certainly true to say that Swedish painting was for long dominated either by Northern figurative Expressionism, or by the fashions in abstract painting set in Paris during the 'fifties. In recent years, younger Swedish artists seem to have been evolving a new national style, and this exhibition at the Camden Arts Centre gave Londoners a glimpse of the kind of artistic activity which is now taking place in Stockholm.

The artists chosen for the Camden exhibition were, with one exception, in their twenties and thirties, and most of them had exhibited at the Galerie Burén in Stockholm. Since Sweden is a highly industrialised society, it was not surprising to find that much of the work made use of modern materials, such as plastics.

It was interesting, though, to discover a strong tendency towards exploiting the notion of the environment. What was shown at Camden was mostly work specially created on the spot by the artists to fit the gallery space available to them. The environments on show were marked by two characteristic qualities: a sense of elegance and an attraction towards Surrealism. Ulrik Samuelson's weird room-setting owed something to Claes Oldenburg's celebrated *Bedroom Ensemble* of 1963, which Londoners saw in 1969 at the Hayward Gallery's 'Pop Art' exhibition. But while Oldenburg made a loving re-creation of a picture from an old glossy magazine, with Samuelson one tended to feel that one was inhabiting a set where a film about Beardsley was being made. If this amounts to saying that the Swedes have continued to give a strangely literary twist to what is by intention an extremely anti-literary art form, then such a paradox helps to give some idea of the unpredictable nature of the latest Swedish art. The success of the exhibition with most of the London critics was a particularly healthy sign in a city where the art scene has sometimes seemed altogether too dominated by American ideas about art.

Sivert Lindblom Pillars 1968–9
Wood

Leif Bolter Pulsating Space 1967–8
Aluminium

Lars Englund Volume 1968–9
Neoprene

William Pye

Redfern Gallery *May - June*

This was the second one-man exhibition of a sculptor who belongs firmly in the mainstream of current developments in British art. Born in 1934, Pye is a characteristic member of a generation which has established itself in Britain and which is beginning to make some impact abroad. The forms which he used in this group of sculptures were mostly derived from the shapes of commercial steel tubing: the kind to be found snaking across factory ceilings or winding through an industrial site. An interesting innovation this year was the satin-finished, unreflecting surface on a number of pieces, causing the hard metal to look vulnerable and proddable.

Pye's work relates on the one hand to ideas about Minimality, and on the other to the new effort – very visible among our younger artists – to come to terms with technology and the technological environment. Pye has worked in co-operation with bodies such as the Stainless Steel Development Association; the British Oxygen Company Limited, and T.I. Stainless Tubes Limited.

As so often with British art, however, the result

Kaa 1968
Chrome-plated steel (Edition 4)
14″ × 12″

seemed a good deal less radical than the intention. William Packer, in his catalogue introduction, spoke of 'a single image, to which architectural and organic characteristics are both integral'. What this seemed to mean in effect was that Pye was looking for ways to marry the old, romantic, English semi-surrealist

tradition of Henry Moore with a new industrial toughness. There were also signs that he has learnt a great deal from the example of Eduardo Paolozzi. The exhibition presented work which was always coherent and well thought out, but which had considerably less physical impact than might have been expected.

Michael Tyzack
and Bill Featherston

Richard Demarco Gallery, Edinburgh

June - July

Michael Tyzack was having his first one-man show for some time – the fact that it was held in Edinburgh and not in London was a sign of the new decentralisation of the art world in Britain. The artist's previous work, including the painting with which he won the John Moores Liverpool Exhibition prize in 1965, had given evidence of a fine colour sensibility but also seemed to show rather too decorous and decorative a feeling for shape. The new paintings are, most of them, larger than his previous works, indicating that he has gone a long way towards remedying this defect. The most successful works on view consisted of pairs of triangular canvases locked together, to make trapezoidal shapes. The colour was used both to assert the separate identity of each half of a pair of canvases and to lock them together. There was in fact an element of tension which was new to the artist, and which was generated by the pressures of these opposing intentions. Tyzack's colour sense has always been very refined – his only close rival in the management of colour being Robyn Denny. With this exhibition he showed that he was capable of a much firmer architecture than hitherto, and one looks forward to the next.

Bill Featherston has already had a number of one-man exhibitions in Toronto, London, Edinburgh and Glasgow. The sculptures he showed on this occasion were related to the concepts of Minimal art. These pristine shapes of perspex and plastic inevitably reminded one of the work of Americans such as Robert Morris and Don Judd. Unfortunately, Featherston did not seem to have the command of scale which is the

great virtue of the American Minimalists, and his relatively small works tended to look rather toylike, especially in comparison with Tyzack's big canvases.

(*See colour illustration page 72*)

Bill Featherston Sculpture 1969
PVC, plywood and Perspex 15″ × 21″ × 26″

'The Jazz Age'

Brighton Museum and Art Gallery, Brighton *May - June*

Arranged to coincide with the Brighton Festival of Arts, this exhibition was a celebration of the extravagant 'twenties, when the world appeared to plunge into its own champagne bucket in a frenzy of merry-making, and the decorative arts at last began to loose the hold of Art Nouveau.

Organised by John Morley, the Director of the Brighton Museum, and designed by Martin Battersby, author of a recently published book on Art Deco*, the exhibition included furniture, fabrics, glass, costumes, films, graphics, and even cocktails of the period.

Many of the items which were on view are now extremely rare, a large number of them coming from Mr Battersby's own collection. They epitomised the 'high style' of the 1920s: the gilded commodes, inlaid ebony tables, Lalique vases and enamelled silver cigarette-boxes of the *nouveaux riches*. Their design was stylised and angular; fabric patterns (a number were designed by Raoul Dufy) were jazzily geometric.

In an article written for *Art and Artists*, Martin Battersby says:

In 1922, an exhibition of French Colonial Art was held at Marseilles and the consequent use of motifs drawn from African sculpture and textiles by fabric designers, Rodier for instance, familiarised the public eye with a new idiom of form and design. Cubist painting, considered unintelligible and nonsensical by the majority in the pre-war years, was beginning to find a more sympathetic reception in the 1920s, and Picasso's *Three Musicians*, painted in 1921, can be seen to have had a great influence on the decorative arts in subsequent years.

In this show, however, the small selection of fine art contemporary with the period stood rather dully on the sidelines, while the fashion plates of Georges Lepape and Paul Poiret, the costume designs of Erté and Léon Bakst, romped glamorously away with the honours.

And foot fetishists would have had a field day with the abundance of 'twenties men's and ladies' shoes which were on view. The catalogue notes to these were particularly delightful, for instance: 'Gold kid boot with spade toe, green eyelets and stitching' (man's); or

**The Decorative Twenties*, Studio Vista, 1969

A design for a dress in 'crêpe de Rome' from *Art, Goût et Beauté*, Paris, May, 1923, showing an easy chair by Mercier Frères, *c.* 1923.

'Brown metal thread dance shoe with silver straps and diamanté plaque on instep, made by Perugia, Paris, and worn by Mistinguett. Late 1920s.'

Among the droopy chiffons and velvets were a bugle-beaded dress weighing 7 lb. 6 oz.; a pair of stockings in gold metallic thread worn by Josephine Baker at the Folies Bergère in the 1930s, with the printed comment: 'She could not wear them for more than five minutes at a time since they took the skin off her feet'; variously printed paper fans, and, of course, fans with ostrich plumes. Authentic 'twenties jazz records were played, and the cocktails had names like Bosom Caresser, Pink Baby, Between the Sheets, and Tuxedo.

A witty and endlessly fascinating exhibition, it seemed a great pity that it was not able to tour to other parts of the country.

View of 'The Jazz Age' exhibition

Jim Dine

Robert Fraser Gallery *May*

An exhibition consisting of two very large pictures is apt to prove rather a facer for the critics, especially when each of the two shows Jim Dine's special combination of the naïve and the tricky. One painting was greyish: chalked all over its surface were the names of people whom the painter knew or had known. The other had the words 'painting pleasures' stencilled along the bottom; in addition to this there were marks which seemed to have been made by someone trying out a new box of colours, and some flung paint (marked 'thrown').

In effect, this was another contribution to the debate (which raged in other exhibitions too) about the nature and purposes of art. Predictably, Dine got more mileage out of this apparently esoteric subject matter than his colleagues – the press coverage was handsome, and a good deal of it was interviews rather than reviews, so much so that Dine seemed to be reviewing himself. The quote from the artist which concluded the *Sunday Times* piece on him is worth pondering. Dine said:

I've used London as a spa, a kind of rest cure. But it's dead here. Leaving New York I became a kind of mystery man. So they want to punish you. That's the positive thing of exile; it's taken me out of being considered a pop artist.

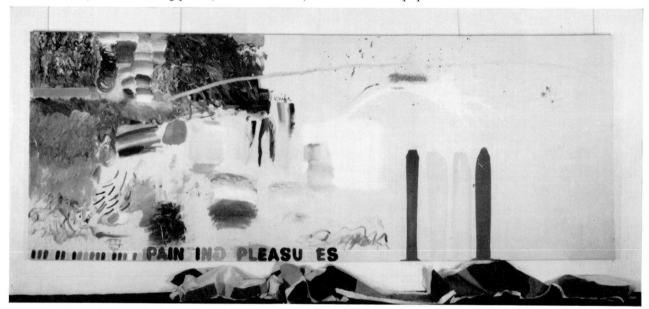

Painting Pleasures 1969 Oil and acrylic on canvas 6′ × 16′

Big Names Painting 1968 – 9 Charcoal on canvas 6′ 8″ × 16′

118

John Hoyland

Waddington Galleries *May - June*

This exhibition at Hoyland's regular dealer had a very considerable impact on British critics, and few one-man shows during the year under review were greeted with such praise, or indeed with such apparently genuine and generous enthusiasm.

The pictures were very large canvases, organised on mainly similar principles – two large squares of colour against a stained ground, on a longitudinal canvas running either horizontally or vertically to about twelve feet in length. The colour harmonies were particularly sonorous: cascades of opalescent pigment would be abruptly cut short by rectangles of luminous, opaque colour placed firmly across the lower half of the canvas. This richness of palette harks back to the late English figurative-painter Matthew Smith, and is quite outside the accepted tradition of British art. The handling was deliberately rough with various accidental trickles and smudges of paint left to show the artist's strongly physical process of working.

In Hoyland's work a comparison with American colour-field painters of the Noland-Olitski group seems inevitable, and it is interesting to note that there are marked differences as well as similarities. Hoyland, for example, retains a lingering allegiance to the ideas and the technical practices of Abstract Expressionism, which makes him seem much less 'pure' than his American colleagues. The principles of pictorial organisation which he employs have a traditionally architectural side, they are not merely a means of activating the colour, and it is still possible to see traces of Hoyland's early infatuation with Nicholas de Stael. There is, for example, a kinship with de Stael's late landscapes. Perhaps for these reasons Hoyland's work has always been much less well received in America than it is in Britain. His tendency to try to achieve a working compromise between the Continental and the trans-Atlantic tradition makes him an especially typical figure among British artists. (*See colour illustrations page 39*)

Trevor Bell

Greenwich Theatre Art Gallery

May - June

This was an exhibition of works on paper (done between 1964 – 9) by Trevor Bell, and was subtitled 'Indulgences and Disciplines' – to which title there is little further to add.

The works swung between expressionistic circles, lines and stabs of colour on a white ground, to carefully laid out geometric drawings on grey and muted backgrounds; from Matisse-like cut-outs of the female nude, to folded 'origami' paper shapes pressed flat beneath the glass of the framing. Bell's last exhibition in a commercial gallery was at the Waddington in 1964. However, the Demarco Gallery, Edinburgh, are planning a major show in June, 1970, which will include his more recent constructions in three dimensions.

In fact, Trevor Bell seems to be one of the best known of a number of artists who are gradually making careers for themselves outside the tight circle of the London exhibition circuit. Their difficulty is, of course, that the reviewers tend to focus their attention only on what happens in the West End.

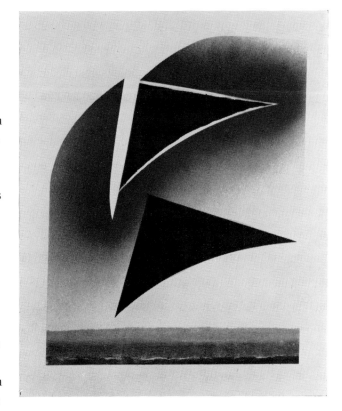

Pair 1969
Mixed media on paper $20\frac{1}{2}'' \times 25''$
Courtesy: Richard Demarco Gallery, Edinburgh
Photograph: Diane Tammes

Surrealist Drawings

Annely Juda Fine Art *May - June*

The function of the small, off-Bond Street commercial gallery is, at least in part, to act as a vehicle for the expression of personal opinions or a personal taste. Annely Juda's show of Surrealist drawings was an excellent example of what we may call the 'taste' show. It is impossible at this date to say anything very new about Surrealism, at least in a small compass (a big retrospective devoted to the movement is about due in England). But this finely chosen show of drawings did give a close-up of certain artists. One felt that everything on view had been carefully selected, by someone with a real feeling for the graphic medium. Even fairly slight drawings gave a good idea of the kind of man who had created them. It was fascinating, for instance, to see the difference in 'handwriting' between, say, Magritte and Tanguy. Clearly a 'dealer's show', this was also a service to the public at large – those of them who found their way to the gallery. Big cities ought to offer such modest pleasures, and official bodies often seem rather ill-equipped to provide them.

Hans Bellmer The Hands
Pencil and watercolour 15″ × 6″

René Magritte *Usage de la parole*
Brush and ink drawing 15¾″ × 10″

Jorge Castillo Drawing 1967
Pen and ink 11″ × 8″

Jorge Castillo Drawing 1967
Pen and ink 8¼″ × 5¼″

Mark Boyle

Institute of Contemporary Arts

June - July

Mark Boyle's 'Journey to the Surface of the Earth' was an ambitious attempt on the part of the Institute of Contemporary Arts to celebrate the gifts of an artist who has recently taken his place in the vanguard of the British art scene.

It was in fact the first one-man exhibition to be put on by the Institute in its new premises at Carlton House Terrace. Part of the justification for this generosity was the variety of Boyle's creations, and also the scale on which he attempts to work; for example, the visitor entered the exhibition through a vast darkened space, upon one wall of which was projected a constantly changing 'dance' of shapes and colour, produced by slides containing fluids which moved under the influence of the heat of the projector.

At the far end of the I.C.A. gallery there was a wrap-around cinema environment showing movie-camera amplifications of various natural phenomena: flames, the movement of water, etc. In addition to these blown-up projections, the gallery walls were hung with a number of Boyle's studies from his London project. Giant mouldings of urban street surfaces, picked at random and copied to perfection by the Epikote resin process. The actual sites were chosen by throwing darts haphazardly into a London street map. A further section of the exhibition was devoted to 'finds' from a dig by the 'Institute of Contemporary Archeology'. The site chosen for this experiment turned out to be that of an abandoned factory which had once made garden statuary of an appropriately Graeco-Roman kind.

Obviously this was an exhibition in which theory counted for much, and the I.C.A. issued an interesting statement by Boyle in its May 1969 *Eventsheet*. This read in part:

My ultimate object is to include everything. In the end the only medium in which it will be possible to say everything will be reality. I mean that each thing, each view, each smell, each experience is material I want to work with. Even the phoney is real. I approve completely of the girl in Lyons who insists that it's real artificial cream. I want to work also with the picturesque. There are patterns that form continuously and dissolve; and these are not just patterns of line,

The Sensual Laboratory Light on film
Institute of Contemporary Arts

The Sensual Laboratory Light on film
Institute of Contemporary Arts
Photographs: John Claxton

121

shape, colour, texture, but patterns of experience, pain, laughter, deliberate or haphazard associations of objects, words, silences, on infinite levels over many years: so that a smell can relate to a sound in the street to an atmosphere noticed in a room years ago. I believe that the electric stimulus given to the brain by these interlocking patterns of reality is the same impulse – though for me by comparison they are luminous and strong – as the aesthetic pleasures generated by brilliant beautiful works in other media.

'Aesthetic' in almost a Wildeian sense was just what the exhibition turned out to be. 'Journey to the Surface of the Earth' had a kind of finical elegance – the environmental film show in particular seemed like a modern equivalent of the Venetian decorative painting of the eighteenth century, and one could imagine a modern ballroom decorated to perfection with constantly moving frescoes of the kind Boyle creates.

But, like a Tiepolo ballroom, the film-environment needed people to bring it to life – it was at its best as something communally, rather than separately, experienced.

Mark Boyle The Artist at Work
Institute of Contemporary Arts
Photograph: John Claxton

Mixed Exhibition

David Hendriks Gallery, Dublin *May*

Arts Council Gallery, Belfast *June*

This exhibition, which was organised by the David Hendriks Gallery of Dublin and the Arts Council of Northern Ireland, with the help of Denise René of Paris and Hans Meyer of Krefeld, Germany, was mostly devoted to kinetic art. It contained characteristic works by, among others, Heinz Mack, Julio Le Parc, Jesus Raphael Soto, Luis Tomasello, and Günther Uecker. Though it is possible to see a good group of kinetic works in the Tate collection, until recently this school had had few showings elsewhere in the British Isles. And since the demise of both the Signals and the Indica Gallery, there have rarely been any temporary exhibitions of kinetic art, even in London.

The show in Dublin and Belfast could therefore be taken as evidence that the policy of decentralisation in the arts was at long last beginning to take root, and that provincial galleries would no longer be the perpetual poor relations of the British art scene.

Heinz Mack Light-Screen in a Landscape 1969
Aluminium and acrylic

Pierre Bonnard 1867 - 1947

Arthur Tooth & Sons *June - July*

This exhibition contained thirty-one paintings by Bonnard, most of them never previously exhibited. They ranged in date from 1896 to the mid thirties. Unknown works, drawn from the artist's estate, as these were, are apt to be what the picture-trade calls 'scrapings from the studios'. Astonishingly, the quality at Tooth's was uniformly high. John Russell, in a perceptive catalogue introduction, spoke of the way in which the artist 'tyrannised his subject-matter, bent space to his will, made colour do things that colour had never done before'. It is perhaps for this reason that Bonnard retains his importance for contemporary painting. It was surprising how many pictures on exhibition in London during the year under review contained at least some detail which was a reminder of this formidable Frenchman. (*See colour illustration page 66*)

Pierre Bonnard
Interieur, autour de la table c. 1906
Oil on paper
$18\frac{7}{8}'' \times 24\frac{3}{4}''$

Ernst Ludwig Kirchner 1880 - 1938

Marlborough Fine Art *June - July*

In his review of this exhibition Bryan Robertson described Kirchner's achievements as 'small, sad, but real'. One might perhaps wish to challenge the first of these adjectives.

Robertson hit, all the same, on the conflict which is at the very centre of Kirchner's work when he said:

. . . the central nerve of the painting is undermined by neurasthenia: the paint goes through the motions of emphatic touch, the colour tends to boldness among primary reds, blues and yellows, the drawing implies an expansive freedom even when serving the needs of distortion. What is physically obvious is a dry, scratchy, thinness in the paint which suggests desperation rather than boldness; the drawing is circumscribed by dramatic clichés, the colour lacks true vivacity and is restricted by harshly imposed schematic limits.

The Marlborough's exhibition was a remarkable one for a commercial gallery to mount, because it gave such a good idea of Kirchner's best qualities and contained a wealth of pictures from what is generally considered his best period – the years between 1911 and 1916. One of the striking things about a great many of his works is the alarming exactness with which they catch the harshness and cruelty of modern urban life. Prices for expressionist paintings have been rising steeply on the London market, partly in response to the shortage of good French pictures of the same period. But it is also clear that Kirchner's view of the world is often shared

by those artists of our own day who do figurative work.
This applies even to English artists, though the context
they work in seems a gentler one. The comparison with
the Howard Hodgkin exhibition at Kasmin, and even
with the Leonard Rosoman show later in the year at
Roland, Browse and Delbanco, was instructive.
(*See colour illustration page 69*)

Portrait of the Poet Frank 1917
Oil on canvas $27\frac{1}{2}'' \times 23\frac{5}{8}''$

Edward Gordon Craig 1872 - 1966

Piccadilly Gallery *June - July*

This exhibition was devoted to the drawings and watercolours of actor, artist, designer, producer and writer Edward Gordon Craig. It ranged from 1898 to 1908, covering the frenetic early years when Craig gave up acting to apply himself wholeheartedly to producing new concepts in the theatre.

His revolutionary ideas on lighting, the use of gauzes, and so on, are now theatrical history and need little further mention here. What this exhibition made evident was that Craig's sensitive draughtsmanship showed him to be a really fine artist, with a sharp eye and a free, if delicate, hand. Some of the works had the vigour and style of a Lautrec, but he was obviously much influenced by whatever he came across, from Daumier to Degas, Art Nouveau to Art Deco. All was grist to this brilliant and prolific man's mill. It leaves one wondering – rather selfishly – what he might have achieved in the area of fine art had he chosen to concentrate upon that alone. Yet perhaps he was too eclectic to rank among the very greatest. The quick sensibility which serves so well in the theatre can be a hindrance elsewhere.

To anyone with an interest in draughtsmanship, however, the show was a delight. Gordon Craig had the real draughtsman's gift, in that the lines he used seemed always to translate his immediate feelings and impulses. His drawings were always a flexible and spontaneous response to the world.

Imaginary Portrait of Napoleon 1902
Pencil and wash sketch $12\frac{1}{4}''\times 10''$

'The Earthly Paradise'

Fine Art Society *June - July*

The Fine Art Society's 'The Earthly Paradise' exhibition was timely. With interest in Victorian painting running high, it was ingenious as well as instructive of the gallery to produce such a comprehensive selection of work by the almost forgotten Birmingham Group of Painters and Craftsmen and their associates, F. Cayley Robinson and F. L. Griggs.

An exceptionally informative catalogue introduction by Charlotte Gere provided a picture of a group of artists deeply involved at that period with technique, and especially with reviving the use of tempera, in which one of their members, Joseph Southall, was a pioneer. Certain members of the group became proficient at jewellery-making, enamelling, and stained glass work, while others did book illustration and etching. These activities were considered practical aids to making a

Frederick Cayley Robinson, ARA, RWS
The Long Journey 1923
Tempera, watercolour and pencil $13\frac{5}{8}'' \times 18\frac{1}{2}''$
Collection: Lord Blanesburgh

Frederick Cayley Robinson, ARA, RWS
Lesson Time 1921
Mixed media on board
$10'' \times 13\frac{1}{2}''$
Collection: Lord Blanesburgh

living while continuing to paint pictures, as well as a contribution to the ideals of Morris and the Arts and Crafts Movement, in which they all fervently believed.

Exquisite examples of the jewellery, made by Georgina Gaskin, were on view in the exhibition, but the chief area of interest was the paintings and in particular, their subject matter: boats bobbing in a harbour under the light of a full moon; fond mothers saying goodnight, or elder sisters reading bedtime stories, to angel-faced children tucked up in cots; family picnics in the woods;

flocks of sheep on a hillside; a sprinkling of fairies, and a few Guinivere's in distress – these pictures were drenched in the kind of Victorian sentiment that artist Peter Blake revives with such affection in his current work.

More than one critic seemed incredulous to discover that these paintings were being done in England, at a time when in Paris something called Cubism was just coming into being. Many of the works on view in fact post-dated the Vorticists.

Severini 1883 - 1966

Grosvenor Gallery *June*

The Grosvenor Gallery staged this show as part of a series devoted to twentieth-century Italian art, which has always been a speciality of the house. It was, as the organisers claimed, 'the first exhibition of Severini's work in London since 1913'. A pity, then, that the result was so scrappy. But perhaps, even if the show had been more complete, Severini would still have emerged as an

artist whose historical importance outweighed his talent.

Severini met Boccioni and Balla in 1900, and it was the former who inspired in him a desire to paint. He went to Paris in 1906 and was introduced by his compatriot Modigliani to the famous 'Lapin Agile' and its circle of artists and poets. Later, he formed a link between the avant-garde in France and the Italian Futurists, whose movement he joined. There were not many strictly Futurist works in the exhibition, which was a pity, as these are certainly Severini's most

L'Automobile en Course 1912–13
Oil on canvas $8\frac{3}{4}'' \times 19\frac{3}{4}''$
Private Collection

attractive things. An oval Cubist still life, in the manner of Braque, illustrated his decorative gracefulness and good taste, but also his lack of feeling for form – something which is better disguised in the swirling agitation of the Futurist paintings.

With the current fashion for Art-Deco (which owes at least as much to Futurism as it does to Cubism), London is probably due for a revival of interest in the Futurists. The Tate Gallery, for example, purchased an important Futurist period Severini during the year. One must hope that other showings will do more justice to their subjects.

Le Boulevard 1910
Oil on canvas $25\frac{5}{8}'' \times 36\frac{1}{4}''$
Collection: Mr and Mrs Eric Estorick (on indefinite loan to the Tate Gallery)

John Piper

Marlborough New London *May – June*

John Piper has always had two lines as an artist. On the one hand there is the painter of elegant abstracts, and on the other, the topographer. It is the topographer who excites the most affection, as the old story about the artist showing his watercolours of Windsor Castle to the late King George VI serves to illustrate. The King's comment was, 'dreadful weather you had for your visit, Mr Piper'. The anecdote is not pointless as it illustrates very neatly the leading characteristic of Piper's architectural work, which is that he paints buildings because they are vehicles for a mood.

He stated in a note in the Marlborough catalogue:

The titles are the names of places, meaning that there was an involvement *there*, at a special time: an experience affected by the weather, the season and the country, but above all concerned with the exact location and its spirit for me. The spread of moss on a wall, a pattern of vineyards or a perspective of hop-poles may be the peg, but it is not hop-poles or vineyards or church towers that these pictures are meant to be about, but the emotion generated by them at one moment in one special place. They are about what Paul Nash liked to call the *genius loci*. Romantic painting is about the particular, not the general.

This seems an excellent and perfectly coherent summary of what the exhibition was about. Most of the works were small, and nearly all were covetable, as the eager crush at the private view served to demonstrate. Though Piper is a modernist this was modernism in an unadventurous but nevertheless pleasing mood. Oddly enough, in a year when the big paintings continued to triumph, and when we met with younger and younger artists straining their talents in order to paint bigger and bigger pictures for which the market seemed ever more doubtful, this exhibition came as something of a relief.

Piper's watercolours were small things, but they were small things done exceedingly well, the product of immense experience in handling the watercolour medium. Nor was this a case of mere showing-off, of empty virtuosity. Piper's love of architecture, and knowledge of it, have never been in question. However sketchy a particular watercolour seemed, the bones of the building were always there. Work of this kind has an extremely honourable place in the English tradition of art. (*See colour illustration page 31*)

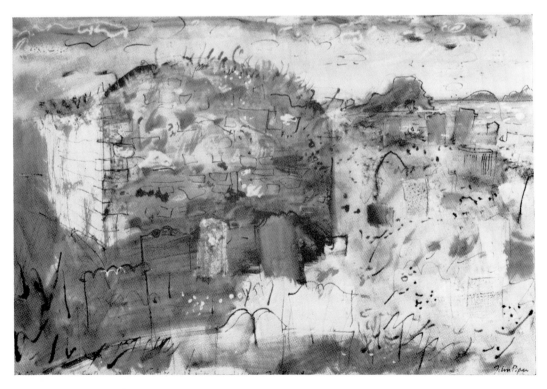

St Columba's Chapel, Mull of Kintyre,
S.W. Scotland 1968
14″ × 21″

Peter Blake

Robert Fraser Gallery *July*

This was clearly an interim show. Blake's watercolours and drawings, though just the thing collectors want, are not his major area of artistic activity. What the exhibition demonstrated was the meticulous, loving care which Blake puts into even his slightest works. His obsession with the illustrators of the nineteenth century took charge here, and even though the subject matter – heads of negresses, chimpanzees, young girls and freckled-faced boys – could be considered timeless, it was nevertheless sometimes difficult to see where enthusiastic pastiche ended and originality began. But perhaps this was the point – Blake is not an ironist, nor is he Pop. He is simply a realist. The re-creation of an historical style is incidental.

Concurrently with this exhibition, in nearby Vigo Street at the Leslie Waddington Print Gallery, Blake showed a new edition of screenprints which took the theme even further. These prints were direct blow-ups of nineteenth-century French postcard illustrations, coyly posing nudes whom the artist bathed in swoony magentas, greens and browns.

Jane and Chita 1969
Watercolour 11″ × 9″

Boy and Chita 1967 – 9
Watercolour 10″ × 8″

'Sculpture in Nottingham'

Midland Group Gallery, Nottingham

June - July

The Midland Group Gallery in Nottingham organised two events in 1969 to coincide with the Nottingham Playhouse Festival. The first, 'Sculpture in Nottingham', was an attempt to put the work of young British sculptors before the eyes of the general public. Sites throughout the city were chosen, photographed and shown to the sculptors who, in many cases, made works specially for their selected positions. Some of the artists who participated in the scheme were: Brian Wall, John Hoskin, Garth Evans, David Hall, Michael Pennie and Tim Threlfall.

Sculptures were boldly placed in the centre of busy thoroughfares, in the foyers of theatres and cinemas, in parks and in the gallery itself, confronting the populace with modern sculpture in the midst of their daily comings and goings. People moving through the city were obliged to look again at townscapes which had become over-familiar; the works were both visual challenges and – finally – friendly objects, existing in the context of ordinary life, reaching out to meet a public nervous of the idea of entering the rarefied interior of the average art gallery. Local firms made an important contribution by providing transportation, materials, and by making up some of the sculptures.

The second event was a mixed media environment in the upper rooms of the gallery, arranged by Jolyon Laycock and Ralph Selby. Spectators were able to participate by writing or drawing over walls covered with blackboards, by recording messages on tape-recorders, by watching, listening or joining in impromptu 'happenings' taking place from time to time. (One event was entitled: 'The Hardware Loop Event Awaits its Human Software'.)

This section formed part of an increased interest in such 'new activities' involving spectator-participation, the use of mixed media, and situations carefully left open-ended.

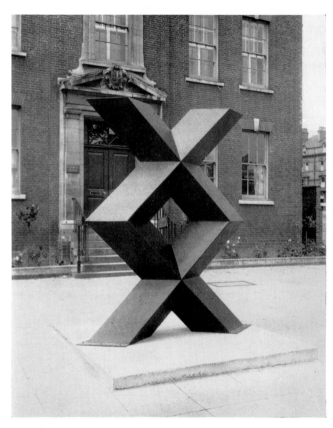

Bernard Schottlander, outside Church House

David Hall, in the Nottingham Playhouse foyer

John Dee, in Old Market Square (city centre)

Brian Wall, outside Castle Gate

Tim Threlfall, in Market Square

Interior shot of Midland Group Gallery mixed media

Robert Downing

Whitechapel Art Gallery *July - August*

Canadian sculptor Robert Downing's first exhibition in
this country transformed the interior of the Whitechapel
Art Gallery into something which looked like a large
fish tank. Pristine, crystal forms in pale green
plexiglass stood like motionless fronds; box shapes
opened out like anemones, polished chrome globes
bulged from the sides and edges of cubical or pyramidal
structures like winking fish eyes. This initial impression
remained difficult to shake off, and it is remarkable that
these precise, geometric constructions, utilising materials
like aluminium, epoxy, perspex and arborite, should
have conveyed so much organic feeling.

Downing, at thirty-five years old, is probably the most
interesting sculptor to come out of Canada, and the
exhibition was the first in a number of exhibitions of
Canadian artists' work planned for the Whitechapel.
According to a biographical note Downing began
experimenting with cuboid forms in 1966. In 1967, he
received two generous grants from the Canadian
Council, and was able to continue his 'love affair' with
the cube – as he himself describes it. His acute concern
for perfection led him to enlist the aid of two
craftsmen, and the impeccable results of this association
go beyond the 'good industrial finish' sought by many
Minimal sculptors.

With the accuracy of a surgeon, he slits through his
cubes, reassembling the angled shapes into serenely
balanced forms, making ever more permutations from
this basic and simple shape.

One of the best pieces, entitled *Column of Revolving
Cubes,* was a totem-pole of transparent green plexiglass
cubes, containing smaller and then still smaller cubes,
on the principle of a Russian doll. There was an
eerie quality to this icily glittering work; the spectator
is drawn towards its centre where the smallest cubes
nestle. In his catalogue introduction, Dennis Young,
Curator of Contemporary Art at the Art Gallery of
Ontario, Toronto, mentions Downing's early 'penchant
for the cabalistic mysteries', and this work seemed
indeed to hold secrets at its core.

The structures like opened-up boxes were interesting
because Downing emphasised the idea by using two
different surfaces for the 'inside' and the 'outside'. One
particularly beautiful work, expanded and poised, was

shinily chromed on the 'inside' and finished in black matt paint on the 'outside'. This series had the appearance of stranded kites, the heavy metal conveying a disarming weightlessness.

The calm and intelligent logic which pervades Downing's sculptures is succinctly summed up by Dennis Young thus:

He remains . . . a sculptor concerned to integrate space and form with material and surface, and his works become a metaphor for reason and measure, poise and clarity, within this complexity. More than gorgeous ornaments, they celebrate a life in which all perception rehearses an inner script and all objects may find an inner locus.

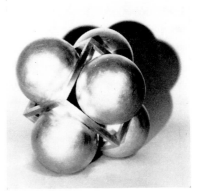

Robert Downing Six Spheres to the Cube 1967
Aluminium and epoxy
35″ × 35″ × 35″
(Maquette in the collection of
Mr Sol Ray, Mexico City)

Robert Downing Cube Cell 2 1967
Aluminium and epoxy
48″ × 48″ × 48″
(Variations in collection of University of Toronto and Montreal Museum of Fine Art)

Jules Olitski

Kasmin Gallery *June - July*

Painter Jules Olitski's exhibition of sculpture appeared in London almost unheralded. The artist had already had a show of sculpture at the Metropolitan Museum in New York – only the third by a living American artist to be put on at that institution. The opening of the Kasmin exhibition, therefore, caused a moment of excitement in the London art world.

But the event on the whole belied the expectations of the experts. John Russell, writing in the *Sunday Times*, conceded that 'Olitski's sculptures are very elegantly drawn: the intensity comes from the assurance with which the *edge* asserts itself'. Yet Russell was also constrained to add: 'take away the sprayed colour, and there remains an anthology of post-Caro sculptural forms'. In fact, the Olitski sculpture show was rather a frost, and one of the year's disappointments.

Was this disappointment at the same time a surprise? Olitski has, of course, a very big reputation as a painter, and the commitment of modern art to the multimedia and intermedia makes us feel, instinctively, that artists should now be jacks-of-all-trades. Yet there has never been any significant trace of sculptural feeling in the veils and mists of colour which provide the characteristic imagery of Olitski's paintings. The idea of the finite boundary is something which, as a painter, he has tended to reject – but it is essential in sculpture.

'Poetic Image'

Hanover Gallery *July - August*

The holiday season generally brings with it something of a slump around the commercial galleries in London, which are inclined to trot out a jumble of unsold works by their artists, usually resulting in mixed exhibitions without theme or purpose.

One exception has always been the Hanover Gallery's summer shows – entitled 'Poetic Image'. These are a feast of evocative objects and paintings, with works by the masters of symbolic reference: Magritte, Nevelson, Dali, Arp, Oppenheim, Louis Lutz and Joseph Cornell.

A seemingly straightforward Magritte landscape included in the 1969 exhibition had one staring hard into the picture in an effort to find the pictorial conundrum one expects in his work. Finally it emerged: of two trees, one was in blossom, the other bore fruit.

The American, Richard Lindner, put in an appearance with silkscreen prints and a watercolour based on his obsessive subject: guys and broads. This is a highly original artist, long overdue for a major British showing.

The same might be said of another American, Joseph Cornell. Like Schwitters, Cornell collects and transforms humble, everyday objects. His 'boxed' landscapes are tiny, poetic worlds; and the three he showed at the Hanover had a cool 'blueness' about them, a strangely salty, at-the-seaside-on-a-sunless-day air. He is fond of using a wine glass as a representation of water, a

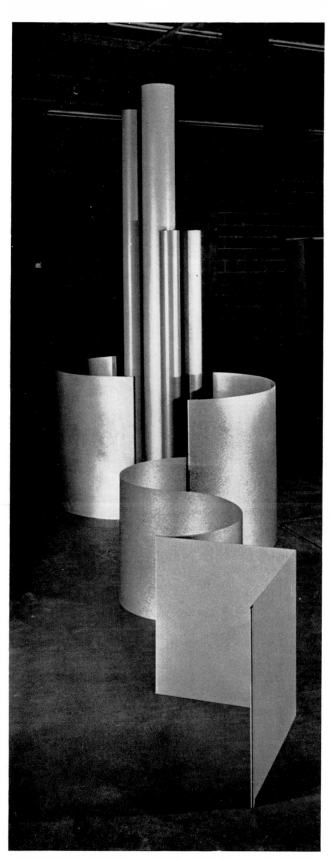

Jules Olitski No. 7 1968
Painted aluminium 9′ × 14′ 6″ × 4′ 6″

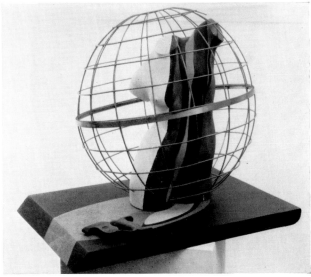

Roland Penrose Captain Cook's Last Trip 1936 – 8
Wood, steel and plaster 28″ × 21½″ × 31¼″

135

delicate bird's egg or a painted golf ball as the sun or the moon, and his peeling, blue paper backgrounds conjure up cloudy, wind-blown skies.

But one of the revelations of this exhibition was a rare piece by the English surrealist, Roland Penrose. Because of his connection with the Institute of Contemporary Arts, it is generally overlooked that Sir Roland is an artist of considerable merit, of all Englishmen the one most deeply involved with the Surrealist Movement. His painted assemblage entitled *Captain Cook's Last Trip*, done in 1936–8, was a very witty piece of proto-Pop.

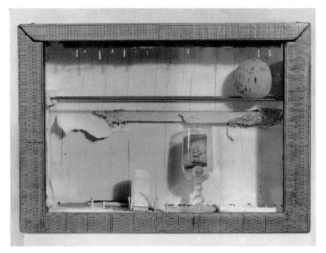

Joseph Cornell The Sailing Ship 1961
Box construction $9\frac{3}{4}'' \times 14\frac{1}{4}'' \times 3\frac{1}{2}''$

Robyn Denny

Kasmin Gallery *June*

Robyn Denny works within strict limits – his colour-range is always narrow, the designs which carry the colour never seem to vary much. Basically, Denny uses a door-shape; a bilaterally symmetrical design which climbs upward from the bottom edge of the canvas. His gift is for activating the curiously indefinable hues which he uses, adjusting the tones so that the colour seems to pulse as the spectator focuses on the canvas.

Such techniques must have their limit, so far as a painter's development is concerned. Denny's 1969 show was 'different': there were some changes to the basic design. But one still got the feeling that he, even more than the other artists of his generation, was simply marking time.

Robyn Denny Time of Day II 1969
Oil on canvas $8' \times 6\frac{1}{2}'$

Robyn Denny Before 1968–9
Oil on canvas $8' \times 6\frac{1}{2}'$

136

Tess Jaray

Axiom Gallery June - July

Tess Jaray's show was in some respects not unlike Micheal Farrell's exhibition which appeared at the same gallery earlier in the year. Miss Jaray is, like Farrell, an artist whose work is related to the dominant mode in abstract painting, without being wholly in the mainstream. She, too, incorporates figurative references in designs which at first glance are wholly abstract. In her case the references are to architectural pattern, though her 1969 exhibition used these motifs less obviously than happened in her previous London exhibitions, which took place at the Grabowski Gallery and at the Hamilton Gallery.

The forms, which before were linked in reticulated patterns suggestive of fan-vaulting, were now scattered over the surface of the canvas, though still at regular intervals. To one critic (Guy Brett, writing in *The Times*) they hinted at 'speed and flight'. Brett's reaction was perhaps not untypical of the London reviewers as a whole. He found that the painter's talent 'seems more for inventing motifs than for handling scale and colour', and added: 'The image is fresh and delicate: only the rather inert pink or buff backgrounds and the pale colours within their shapes detract from this vitality.' (*See colour illustration page 74*)

Millennium 1968
Oil on canvas 84″ × 96″

Mark Lancaster

Rowan Gallery June - July

Lancaster is a legend among younger British artists and this exhibition had been eagerly awaited. As it turned out Lancaster's work was to be a fairly tough dish for even the most devoted followers of the vagaries of contemporary aesthetic theory. Basically, the show concerned itself with the notions of colour applied to a structure and divided by a graph or grid. One got the feeling that a rigorous intelligence was at war with a sensibility which had not as yet quite come to terms with its demands. The rarefications of hard-edge abstraction of this kind are always so subtle that the critic is forced to tread with great wariness, but it is worth echoing the verdict of Bryan Robertson in the *Observer*, who said:

Lancaster might well mistrust the concept (and all is concept in his domain one feels) of inspiration responsible as it can be for thundering lapses in taste and judgment, but I wish he would at least appear to feel more and think less. With so much restraint over the legitimate objects for expression and discipline of pace and style, it is still possible to detect in Lancaster's work the possibilities of a much wilder, rougher and more risky utterance. (*See colour illustration page 27*)

Cambridge Eight 1969
Liquitex on canvas 68″ × 68″

Bridget Riley

Rowan Gallery *July - August*

This was the artist's first one-man show since she won the major prize for painting at the Venice Biennale of 1968. The exhibition consisted of a small group of very large paintings which continued the exploration of themes she had already begun to work with in the most recent canvases shown in Venice. Essentially, this was a statement about the optical possibilities of colour, and the vehicle for the colour was a thin stripe.

Miss Riley shows enormous flair and ingenuity in the use of an extremely restricted format. Guy Brett, in *The Times*, described some of the effects to be seen in the exhibition:

The two paintings with diagonal stripes among the four hanging at the Rowan keep up a kind of constant visual bombardment, whether you are close to them or farther away. Their effect could be compared to a fixed stare. But there is another – of orange, violet and green stripes in a tall repeated N-shaped pattern – in which, as you move away, an eyelid seems, metaphorically speaking, to close over the stare. The colours merge and disappear. Only the white surface tautly sprung with lines remains. This painting has the same thoroughgoing logic as the others, but it mixes it with elusiveness, a quality which dispels the element of coldness present in some of Bridget Riley's brilliant designs.

In fact, the argument aroused by this show was not about its technical brilliance, which was conceded by critics and spectators alike, but about the emotional effect of the painting. Many visitors were inclined to feel that the works were the experiments of a scientist with an interest in optics; Miss Riley herself has always maintained that her paintings are the product of emotion and are meant to express emotion. What was not in doubt was the command of scale, which still makes Miss Riley one of the two or three most important painters of her generation currently at work in England. (*See colour illustration page 75*)

Turquoise Red/Grey Study for Cataract 1967
Gouache on graph paper 28″ × 41″

'Art in Wales in the 20th Century'— 56 Group Wales

National Museum of Wales, Cardiff
July - August

This was the most ambitious of a whole series of exhibitions by the 56 Group Wales – others included showings at the Municipal Gallery of Modern Art, Dublin, in November to December 1968; at the Grosvenor Gallery, London, in January and February 1969, and at the Arts Council Gallery, Belfast, during the same period; then at Brooke Park Gallery, Londonderry, in April 1969.

The 56 Group Wales was first formed in 1957, the idea

being to show that Welsh art need not necessarily be neo-romantic, figurative and nationalist. Members have never been chosen from the point of view of style; the criterion has been the wish to include those whose works seem to make a real contribution to the artistic scene in Wales. Because the base for modern art remains comparatively small in a small country, artists of many different persuasions are more willing to exhibit together than they might be in England. The result has been exhibitions which were stimulating in their contrasts. With the growth of art education in Wales, and especially with the experiments initiated by Tom Hudson at the Cardiff College of Art, the Group has, nevertheless, taken on a definable character which is not to do with style, but with the attitude adopted by the artist towards the work of art and its purposes.

Compared with any recent mixed exhibition in London, the 56 Group Wales show in Cardiff offered the visitor a remarkable range of experiments in different media, and suggested perhaps more clearly than any other show of the year, the degree of technological involvement now possible to the modern artist. Participating artists were: Mervyn Baldwin, Laurence Burt, Arthur Giardelli, Tom Hudson, Robert Hunter, Heinz Koppel, Bryan Macdonald, Eric Malthouse, Keith Richardson-Jones, Eric Rowan, David Saunders, John Selway, Terry Setch, Christopher Shurrock, Jeffrey Steele, Anthony Stevens, David Tinker, Norman Toynton, Michael Tyzack, Alan Wood, Ernest Zobole.

Tom Hudson Industrial Spectrum
Acrylic and polyester resin, glassfibre and aluminium
48″ × 30″ × 12″

Christopher Shurrock 'No. 29/composite Variant/68'
1968
Acrylic sheet and ink, wood and metal 36″ × 36″ × 6″

Jeffrey Steele Duologue
Oil on canvas 30″ × 40″

'Young & Fantastic'

Institute of Contemporary Arts *August*

This exhibition was designed as a follow-up to the show of new British art organised by Mario Amaya and the Institute of Contemporary Arts for the New York department store, Macy's, in 1968.

Once again, Mr Amaya selected the artists to be shown; the exhibition was seen, if briefly, in London before departure for New York, and also – for the first time – to another department store: Eatons of Toronto.

What Mr Amaya decided to illustrate was the

continuing importance of Surrealism in the tradition of twentieth-century art. He spoke of his slected artists as people who explored 'the nether world of dream, fantasy, the unknown, mingled with the blatantly recognisable and banal'. The result was a lively show of relative unknowns, whose work ranged from neo-Pop to Surrealist painting of an almost classical kind. Much of what was on view had a greater complexity of reference than Londoners were used to in the year of the Minimalists. The exhibition rightly indicated the merits of a number of artists whose work has been somewhat neglected by fashionable commercial galleries, among them David Oxtoby, whose paintings hinted at rich

erotic fantasies without ever stating them quite specifically; and Norman Stevens, whose boldly decorative work kept Pop and Surrealism in tension in a framework which often seemed to owe something to Art Nouveau. It was also interesting to see work by the young sculptor Nigel Hall, who has scored very considerable successes in recent years in both Paris and Los Angeles, but who has yet to have a one-man exhibition in London.

There were also large, breathtaking paintings by Brendan Neiland, an extremely promising newcomer from the Royal College of Art – his work is discussed elsewhere in this book in connection with their Diploma show and with the exhibition at the Royal Academy entitled 'Big Pictures for Public Places' later in the year.

The 'Young & Fantastic' exhibition was clearly the product of an intelligent and thoughtful approach to the contemporary British scene, and served to pinpoint certain new tendencies among younger artists. There are, after all, a good many painters who still feel that their vocation is to paint: to discover images and put them on canvas. But it is hard for such men to find a valid idiom in the present situation. The 'Young & Fantastic Exhibition' suggested one promising line of approach. One suspects, however, that such a tendency must await a major retrospective survey of the Surrealist Movement to show its strength.

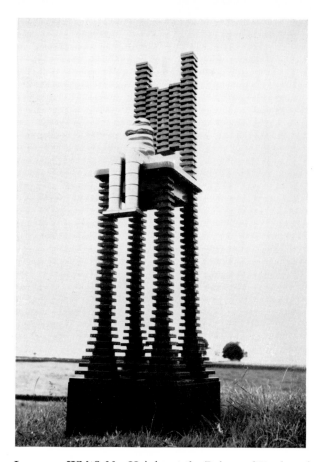

Laurence Whitfield Heinke at the Palace of Engineering
1963
Wood $51'' \times 16'' \times 14''$

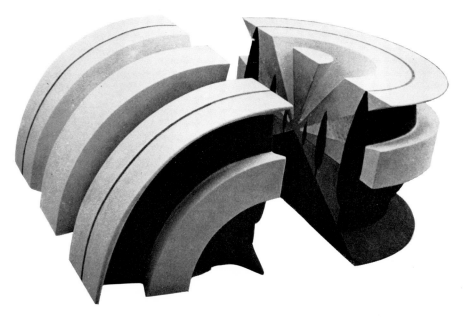

Glynn Williams The End Pieces 1969
Wood, polyester resin, nylon flock (in two pieces)
$2' 3'' \times 4' \times 6'$

David Oxtoby Knowledgeable Creators Conclusion
with Double Veg. (detail) 1968 – 9
Cryla, aquatec and oil on canvas 5′ × 8′
Courtesy: Redfern Gallery
Photograph: Adrian Phipps Hunt

Norman Stevens Cactus 1968
Airbrush and watercolour 18″ × 23″
Courtesy: Hanover Gallery
Photograph: Adrian Phipps Hunt

Six Royal College of Art graduates

Oxford Gallery, Oxford *August - September*

The Royal College Diploma show was put on for such a brief period that it was good to see some of the young artists whose work appeared in it being given another airing elsewhere. The fact that the Oxford Gallery confined itself to work by only six artists was also helpful, as it focused attention on some of the most gifted of the new graduates. Brendan Neiland was included in the selection, but his fellow-members of the 'Conservative Abstraction' Group were omitted, for the most part in favour of figurative artists. Besides Neiland, the most interesting exhibitors were probably Raymond Walker, whose *Court Suite* showed a gift for grotesque eroticism; and Paul Eachus, whose complicated abstractions seemed to owe a lot to a close study of Kandinsky and Moholy-Nagy. They were also reminiscent of the diagrams drawn by Renaissance mathematicians. The strange spatial effects in some of Eachus's pictures seemed the mark of an unusually original sensibility, and his work was refreshingly different from current fashions. In fact, 'anti-trendiness' was one of the hallmarks of the show. Only a very bold man would prophesy the immediate future of British art on the evidence presented here, but there was a refreshing vigour about the show.

The participating artists were: Jackie Ball, Roger Corcoran, Paul Eachus, Selwyn Jones-Hughes, Brendan Neiland and Raymond Walker.

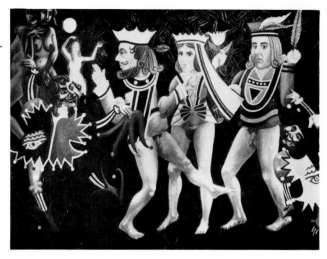

Raymond Walker Court Suite 1969
Oil on canvas 72″ × 54″

Paul Eachus Complex to Move 1969
Acrylic on board 92″ × 63″

Brendan Neiland Yellow Reflections 1969
Acrylic on canvas 5′ × 12′
Collection: Mr Mario Amaya, Toronto

Karel Appel

Gimpel Fils Gallery *September - October*

Karel Appel came to prominence as one of the leading members of the Cobra Group. He was then a prolific artist, who specialised in the modified expressionism which seemed to many critics the most viable alternative to free abstraction in the 1950s. As a Dutchman, Appel is a man with a northern sensibility, interested in the grotesque, the outlandish, the humorous and the outrageous. Like most of his colleagues in the Cobra Group, Appel used, and has continued to use, very brilliant colours, which gave even the most grotesque of his works an air of cheerfulness. In fact, the criticism which has consistently been made of Appel is that with him Expressionism loses its essential ferocity. If one compares, for example, Appel's work with that of an expressionist of the Great Generation, such as the Norwegian Edvard Munch, one is surprised by how essentially superficial it seems. The show at the Gimpel Fils Gallery, Appel's first London exhibition for some time, gave one the opportunity to assess how the artist had developed in recent years. What appeared to have happened was that Appel had changed his techniques without much altering the characteristic imagery of his work. Instead of painting in thick ropes and splashes of oil paint, he now employed an acrylic medium which lightly stained the canvas and gave the effect of watercolour on a large scale. This change of technique did not strengthen his work, because the kinetic energy of the brushstroke had always seemed an essential part of what he had to say as an artist. The new medium deprived it of its force. Though it was good to see an exhibition by a distinguished European painter in London, this was not the kind of thing which had much chance of converting young British painters from their American influences.

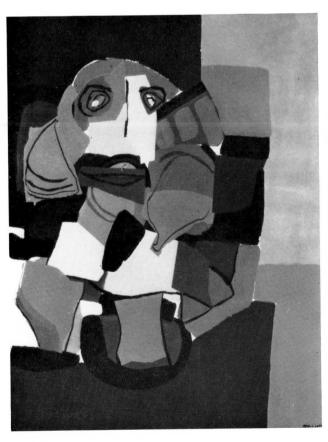

Femme Cubiste 1968
Acrylic on canvas $65\frac{1}{2}'' \times 49\frac{1}{2}''$

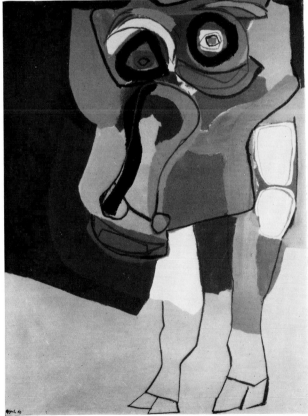

Une Vache 1969
Acrylic on canvas $63\frac{3}{4}'' \times 48''$

Henry Inlander

Roland, Browse & Delbanco

September - October

Before he began to exhibit at Roland, Browse and Delbanco, Inlander had a long succession of shows at the Leicester Galleries, when they were at their old premises off Leicester Square. In addition, he has appeared at the John Moores Liverpool exhibitions of the late 'fifties and 'sixties (a picture of his was hung this year) and has more recently been seen at the Royal Academy Summer Exhibition. This perhaps serves to define his allegiances: in British terms, he is a liberal.

His 1969 exhibition was perhaps his most impressive so far. The larger canvases in particular, such as *Summer River No. 1*, showed a firm grasp of the possibilities still open to the traditional landscape painter. The French *intimistes*, such as Vuillard, were one influence; so was the British romantic tradition. But the way the composition was organised into bands also suggested the work of American abstract painters such as Kenneth Noland. It would not do to give Inlander the kind of position which is perfectly properly given to Milton Avery in the recent history of American art. But he nevertheless has something of his own to say, and says it well. His exhibition was a reminder that modernism is less monolithic than critics are apt to make out. (*See colour illustration page 78*)

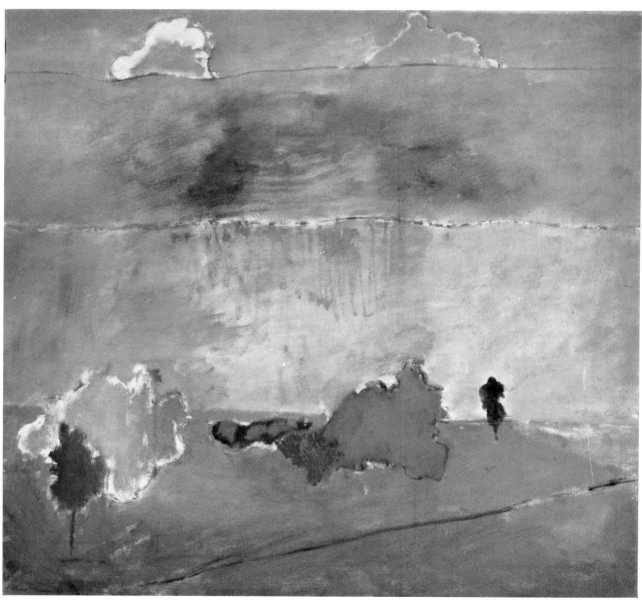

Aniene Valley Oil on canvas 32″ × 36¼″

William Roberts, R.A.

d'Offay Couper Gallery *September*

A small but well-selected retrospective of William
Roberts's drawings and watercolours, spanning the
period 1915 – 68, this show served as a reminder that
leaders of the avant-garde can easily, a few decades
later, find themselves in a very different context (the
Royal Academy Summer Exhibition, for example)
without any great change of style or intention. Guy Brett

points out, in *The Times*, that Roberts has more than a
little in common with Pop art. And of course, he began
in the Vorticist camp – in other words, as an English
disciple of Futurism. But this implies no deviation in
course – rather the opposite, for Pop attitudes are a
great deal more like Futurist ones than is commonly
supposed. It is at least arguable that the contemporary
English avant-garde has progressed hardly at all from
the point where Roberts began, as a subsequent show at
the same gallery, 'Abstract Art in England, 1913 – 1915',
went to prove.

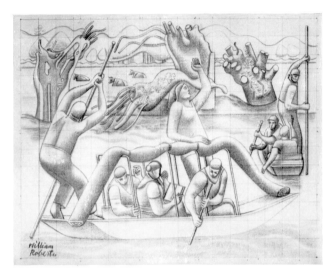

Primrose Hill 1934
Pencil and watercolour $9'' \times 11\frac{1}{2}''$

A Windy Day *c*. 1943
Pencil $6\frac{1}{2}'' \times 8\frac{1}{2}''$

Stassinos Paraskos

Walton Gallery *September - October*

Stass Paraskos teaches at the Leeds College of Art. In
some ways his plight is typical of that of the artist
established in the provinces but without a real foothold
in the metropolitan art-establishment. If Paraskos had
not been the central figure, some years ago, in a
controversy about the indecency or otherwise of some
pictures of his which were shown at the Institute
Gallery, Leeds, he would probably be even less known
than in fact he is.

 The record tells us that he has exhibited extensively
in the North of England and in Scotland: at York,
Bradford, Leeds, Manchester, Glasgow, Edinburgh –
but only occasionally in London. His 1969 show was in
a gallery a long way off Bond Street. Yet the pictures

themselves, naïvely figurative, were not only pleasurable
to look at but highly individual. There ought to be a
place for artists like these in the power-structure, but it
is difficult to see how it can be secured for them.

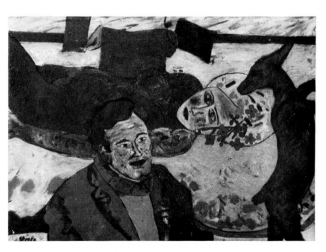

'Lawrence Burt' Oil on canvas $30'' \times 36''$

Anthony Green

Rowan Gallery *October*

Anthony Green is supposed to be contemporary art's tame primitive. He paints colourful, awkward pictures of his own family life, and appears in most of them himself – a scarecrow figure in blue jeans and a beard. This exhibition was his fifth at the Rowan, a gallery who normally show the British 'cool' school, but who appear to have had Green left upon their doorstep like a foundling child.

Despite his 'naïve' and quirky style, Green underwent the conventional art school training, but with highly unconventional results. The pictures here were mainly based on a recent trip made, along with his domestic entourage, to California.

In many of the pictures the edges of the canvas or board had been shaped off at points convenient to the composition: around a half-encircling garden path, a rainbow; or stretched out like an arm to accommodate an extra tall palm tree. One painting in particular looked like a parody of the Statue of Liberty, but, say, West Coast style. It was a close-up view of his wife Mary (from the top of her bare nipples upward) in carefully regulated hair-curlers – set like Liberty's crown – and a halo of little white clouds surrounding her head, all against a too-bland summer sky and with a couple of twin towers poking up from the lower edge of the

picture. This was a shrewd and amusing painting, and it is these elements in Green's observation that make one feel that rather than our laughing at Green, he, behind the childlike masquerade of his pictures, is laughing at us. (*See colour illustration page 82*)

Anthony Green The Morning Cuddle 1969
Oil on board 68″ × 72″

Leonard Rosoman

Roland, Browse & Delbanco Gallery

October - November

This was one of those unexpected exhibitions that crop up occasionally among the commercial galleries' yearly offerings. The whole show consisted of paintings and gouaches inspired by John Osborne's play *A Patriot for Me*. Since one is frequently puzzled by the lack of connection between literature and the other arts in England, it was interesting to see what the artist would contrive to make of his subject. In approaching it, Rosoman had two advantages. One was his passion for the theatre, and the experience gained with projects such

as the Diaghilev Exhibition in 1954, and the Shakespeare Exhibition ten years later. The other was the picturesque quality inherent in the play's setting.

The exhibition showed his professional skill in full measure. These were soundly constructed figurative pictures, always interesting and amusing to look at, often ingenious in composition. They were also very successful in catching the spirit of the play – its furtiveness, coarseness, and tawdry glitter. Precisely those qualities were deployed which many art schools are seemingly afraid to inculcate into their students (see our introduction to this volume). Why, then, was the total impact of the exhibition so muffled?

Chiefly because Rosoman gave the spectator the feeling that he had not dared to experiment enough. The Diaghilev Exhibition, which he designed, is now

generally recognised as the grandaddy of all mixed-media experiments, at least in Britain. One would never have guessed from this show that such experiments were possible. (*See colour illustration page 80*)

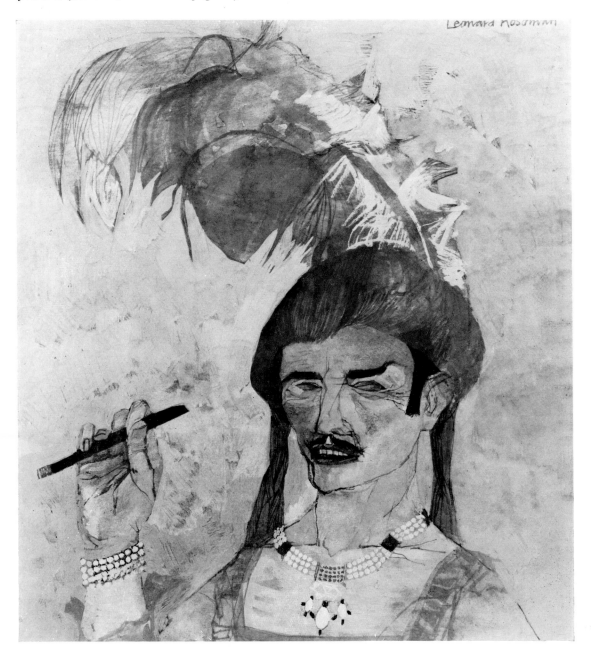

Leonard Rosoman Study – Officer in drag, front view
(Act 2 Scene 1)
Gouache $15\frac{1}{4}'' \times 14\frac{1}{2}''$

Mario Dubsky

Grosvenor Gallery *September - October*

On reflection, this was perhaps the best 'first' show of the year. For an artist who had never had a one-man exhibition before, the large spaces of the Grosvenor Gallery presented a fairly formidable challenge. Dubsky rose to meet it with admirable confidence. His pictures, all of them square in format, showed heavy areas of colour, applied in irregular blocks and strips and framed within a painted border. The handling was rather coarse; the colour admirably sonorous. A series of drawings and collages showed the process by which the bigger pictures were built up, and demonstrated a fact one might have guessed from the start: that Dubsky is an unfashionably deliberate painter, and that his compositions, for all their irregularity, are carefully planned. This was new art, but created by the old method, whereby the picture is produced through a series of clearly defined stages. The painterly handling could not disguise the reliance placed on preliminary black and white sketches, which defined a pattern that was afterwards completed in colour.

Dubsky was awarded a Harkness Travelling Scholarship to the U.S.A. this year. Despite this mark of official approval, he is, of course, an isolated figure in a scene more and more hostile to traditional processes, and more and more obsessed with mixed-media experiments and Minimal art. For this reason it would be rash to guess at his future development. It seems certain that more will be heard from him. (*See colour illustration page 80*)

El Paso 1967 – 8
Oil on canvas 74″ × 74″
Photograph: Hugh Gordon

Edward Middleditch

New Art Centre *October*

Middleditch originally exhibited at the Beaux-Arts Gallery, and belonged to the new realism of the 1950s in England. This exhibition showed the long distance which he had travelled since those days. He is still a figurative painter, but natural forms are now subjected to a pattern-making process which results in decorative works with a quasi-mystical air. Though Middleditch's early admirers may regret the loss of vitality which this change seems to represent, it was fascinating to see an artist trying to extend his range in an art world where most painters seem obliged to stick as closely as possible to the brand image they have made for themselves. The pity of it is that such attempts at growth (see our comments on Tim Scott, page 87) often seem to bring a dilution of the artist's essential talent. (*See colour illustration page 79*)

Formal Landscape 1 1968
Acrylic on paper 28″ × 41″

Big Pictures for Public Places

Royal Academy *September*

This was a good idea spoiled for want of care. The young or youngish artist who paints large pictures has great difficulty in finding opportunities to show his work. He also finds it hard to make contact with the right sort of patron – an important businessman looking for a picture in scale with the foyer of a new office block, for example. The Royal Academy, on the other hand, finds it hard to attract the members of the avant-garde, even though it now wishes to emerge from the citadel of the academic idea.

It seemed a splendid notion, then, to hand over the Academy's huge galleries to a group of young painters, and to bring in the Institute of Directors as backers of the show. Many, if not all, of the pictures were painted specially for the exhibition and the spaces which they were to occupy. But, as Paul Overy commented in his review of the exhibition in the *Financial Times*, 'the idea of the exhibition [was] better than most of the work that [had] been painted for it'.

Six of the artists exhibiting had just graduated from the Royal College of Art – they claimed quite a large share of the 1969 Royal College Diploma exhibition as well. These six have banded themselves together under the label 'Conservative Abstractionists'. They issued a rather turgid manifesto, which read in part:

[The painters belonging to the group think that] painting cannot continue to maintain the teleological outlook, nor employ the same reductive, radical procedures favoured up to now in 20th century art. They agree with Greenberg that the establishment of painting's 'area of competence' by means within the medium has been the main dynamic of Modernist painting, but find that after Reinhardt's contribution the area has been finally set and the main agent of its setting, the Reductive tradition, has outlived its usefulness. Accepting the limits of this definition, they continue formalist painting's live issues to the ideas of linear progress towards the ultimate vanishing point which has distinguished the Modern tradition thus far.

By and large, these younger painters turned out to be devoted followers of the American colour painters, notably Morris Louis and Kenneth Noland. They proved that the apparently simple pictorial formats used by these leading Americans are hard to handle, and grow more difficult with each increase in scale.

Outstanding amongst the members of the group, and curiously different from his colleagues in style, was Brendan Neiland, whose work had already made an impact on the public in the 'Young & Fantastic' exhibition at the Institute of Contemporary Arts in August. Neiland's ideas are not post-Louis or post-Noland, but post-Pop. His huge picture, based it would appear on the distorted reflections seen on a gleaming car body, was the most original in the show.

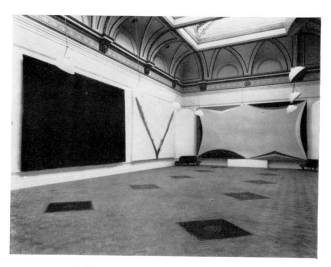

Gallery view, showing works by (left to right) Tig Sutton, Bill West and David Sweet

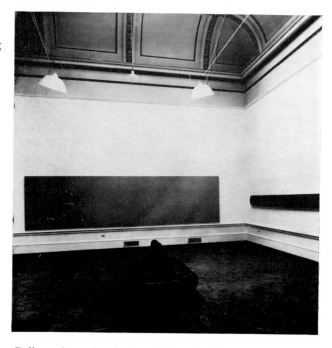

Gallery view, showing works by John Murphy (left) and Peter Waldron

Stockwell Sculptors

Stockwell Depot *September*

Stockwell Depot is a disused brewery in a dingy part of South London which has been taken over by a group of young artists as studio space (these studio co-operatives are among the most significant recent developments on the British art scene). The show was the second which the group had staged in these premises, and on this occasion it was organised by the energetic Nigel Greenwood.

The exhibition provided one of the most interesting art events of the year, both for the shift in social values which it symbolised, and for the high quality of the exhibits themselves. The work on view was rather different from the smooth constructions in plastic which made their debut at the famous Whitechapel sculpture show 'The New Generation: 1965'. The difference between the two exhibitions was a measure of the rapidity with which sculpture seemed to be changing towards the latter end of the 1960s. One very significant point about the work on view at Stockwell was that nearly all of it was environmental in intention. The artists took the large, gaunt spaces at their disposal and tried to manipulate the space itself by means of what they put into it. The most extreme example was the room which Roelof Louw had festooned with ropes. The artist was quoted as saying, 'as it travels, the rope loses its original identity and becomes to some extent abstract'. It was fascinating to note that while the statement justified itself with respect to the work shown at Stockwell, that shown by the same artist in 'When Attitudes Become Form' at the Institute of Contemporary Arts was much less successful.

It would be unfair to give the impression, however, that this was simply Minimal art in its British guise. In fact, this was an anti-stylistic exhibition. As John Russell commented in the *Sunday Times*, these were artists who 'wanted a clean break with a world in which

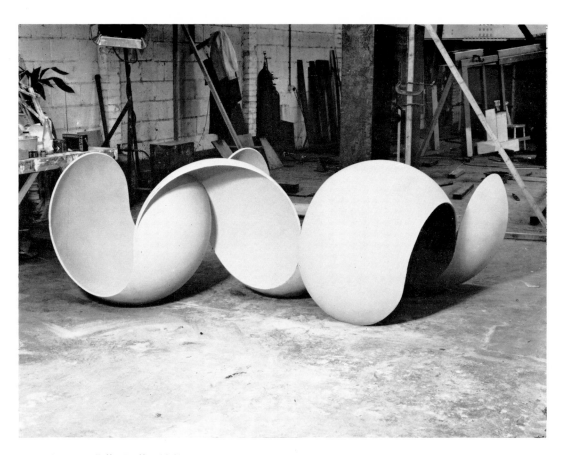

John Fowler Jelly Roll 1969
Fibreglass 36″ × 108″ × 36″

last year's avant-garde sculpture is next year's garden gnome'. The pity of it was that this remained so much a revolt within the art world. When some of the same sculptors exhibited in the open air at Stevenage (ironically enough under the Arts Council's patronage), their work was vandalised by a philistine local public. In addition to this, art which is trying to get away from art intensifies the already acute problems of patronage for young artists.

One hopeful consequence of the show at Stockwell was that it did bring with it the offer of exhibitions elsewhere: in Norway, Sweden and Holland for example. So if the young artists concerned have not yet built up a group of collectors, it seemed clear that they had at least seized the position of leadership in the avant-garde in the opinion of critics and exhibition organisers.

The participating sculptors were: Alan Barkley, Roland Brener, David Evison, Roger Fagin, John Fowler, Gerard Hemsworth, Peter Hide and Roelof Louw.

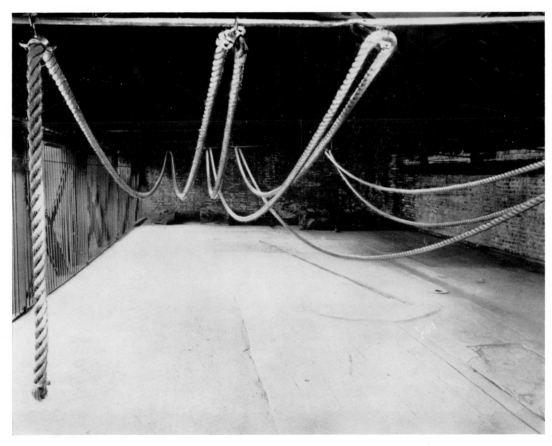

Roelof Louw Rope Piece ($1\frac{1}{2}''$ rope) 1969
336″ × 180″

Charles Biederman

Hayward Gallery *September - October*

The Charles Biederman show at the Hayward called attention to an American artist whom Robyn Denny described, in a catalogue introduction, as 'one of the more neglected, most remarkable, and sustainedly radical artists of our time'.

Among the English artists over whom Biederman has had a marked influence are Victor Pasmore and the late Mary Martin (prizewinner at the John Moores Liverpool Exhibition held later in the year). Biederman, in fact, stems from the Bauhaus, and has labelled himself a 'structuralist'. His most characteristic works are the painted reliefs which he has been making since the middle 'thirties. These reliefs, which consist of numerous brightly coloured flanges presented against an evenly coloured ground, are in some ways like Kandinsky transplanted into a third dimension. The Hayward Show aroused respect rather than outright enthusiasm, as the restriction of technical means became rather noticeable in an extensive retrospective show of the kind presented here. While it was undoubtedly useful to see the precise source material of much which now seems important in British art, this exhibition was not quite the grandiose revelation which advance publicity promised.
(*See colour illustration page 77*)

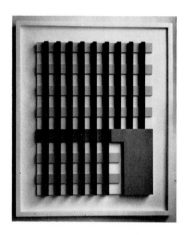

Structurist work No. 2 1937
Paris
Painted wood 35″ × 29″ × 3″

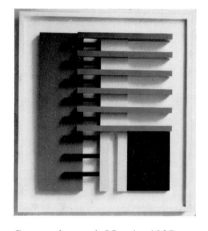

Structurist work No. 4 1937
Paris
Painted wood 36″ × 32″ × 4″

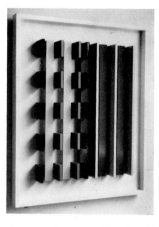

Structurist work No. 5 1937
Paris
Painted wood 34″ × 28″ × 4″

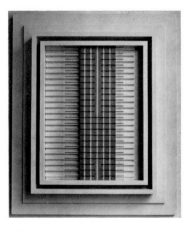

Structurist work No. 9 1939 – 40
New York
Painted wood and glass
36″ × 30″ × 4″

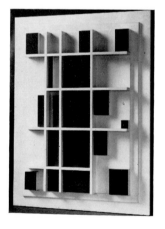

Structurist work No. 6 1939
New York
Painted wood and plastic
40″ × 30″ × 4″
Private collection (not exhibited)

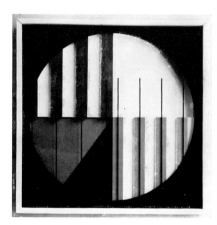

Structurist work No. 6 1940
New York
Painted wood and plastic
25″ × 25″ × 4″
Dr & Mrs Frank G. Chesley,
Red Wing, Minnesota

Clive Barker

Hanover Gallery *October*

Among the younger generation of British artists currently making a reputation for themselves on the international art circuit, Clive Barker stands rather on his own. For, unlike most of his contemporaries, Barker is a romantic. His passion for re-creating in three dimensions familiar icons of twentieth-century art, such as, in this particular show, Van Gogh's hat stuck with candles, or Picasso's wine bottle, candle and ram's skull, is a pursuit based on what are now regarded as old-fashioned ideas of preservation and sentiment. Like a latter-day Midas, whatever he touches turns to chrome, and his works have an often astonishing beauty.

The everyday objects he chooses to petrify in chrome-plate become significant objects: gleaming and permanent, their previous identity indicated by their original shapes, but their presence changed totally by the sense of weight and the hardness of the shiny metal. For some reason, these pieces give enormous satisfaction which must be something to do with their familiarity now combined with a comforting sense of timelessness.

Not all the sculptures in the show, however, are quite so soothing. There is a very ominous look about the chromed hand-grenades, and an uneasy feeling of the presence of a pair of human feet – lopped off about mid-calf and presumably Marlon Brando's – underneath the metallic 'leather' of the cowboy boots sculpture, entitled *Homage to Marlon Brando*. But, then, Barker likes occasionally to disturb. His earlier zip pieces – those kinky black leather boxes, each 'fastened' with an impeccable chromed zip – have now been flattened into two-dimensional silkscreen prints. The result is rather minimal and cool: a closed or half-opened silver zip against a glossy jet-black ground. Yet, they are heavy with suggestion despite the spareness of the image.

The Ball of String 1969
Chrome-plated bonze 6″ high

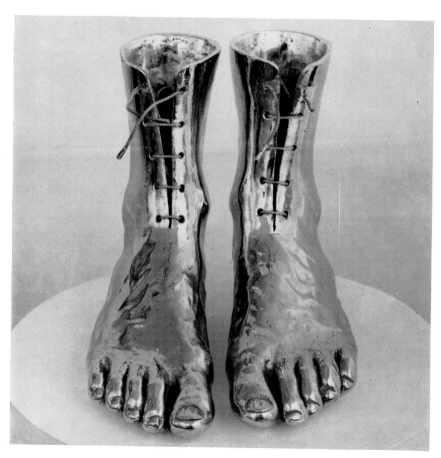

Homage to Magritte 1968
Chrome-plated bronze 8″ high (Ed. 6)

153

'Survey 69 : New Space'

Camden Arts Centre *October - November*

This ambitious show confirmed the Camden Art Centre's new reputation as perhaps the most boldly experimental official gallery in London. Indeed, its manager, Peter Carey, seems to be trying to do the kind of job which commercial galleries no longer feel able to commit themselves to – the exploration of the newest ideas in contemporary art. The exhibitions at Camden have often been concerned with environmental ideas, and this survey showed this concern in a new and even bolder guise. The two large interior spaces available were allotted to the two artists who had shown in the open air at Kenwood earlier in the year: Timothy Drever and Peter Joseph. Both of them, as it happens, had also had one-man exhibitions at the Lisson Gallery. The work they showed now was in each case a logical continuation of previous experiments. Drever adapted his notion of coloured shapes scattered over a lawn to indoor conditions. The shapes were in black and white (black one side, and white the other) and were shown against a black floor in a darkened room. If one turned over a white shape it immediately disappeared, because the black surface now uppermost vanished into the black of the background. The result seemed more intellectually interesting than the work at Kenwood, and less whimsical.

Joseph, always a bold artist, took boldness to an extreme. Allotted the whole of the large gallery, he chose to erect down the middle of it a bright yellow 'wall' of smoothly painted canvas, which served to articulate the already existing space in just the same way as his yellow discs had articulated the landscape at Kenwood. This strange object, neither painting nor sculpture, was directly related to the proportions of the gallery it stood in, and of course played a far more dominant role than the discs. The spatial experience which Joseph offered was certainly something new. One wondered, however, why he insisted on making his construction of canvas, as he had already taken the shaped canvas beyond anything which could be conventionally considered a painting – perhaps lightness and cheapness were the reasons, but the associations remained a little confusing.

Compared to the bold scale of the works to be seen indoors, the two artists shown outdoors seemed rather disappointing. Ed Herring exhibited water-sensitive chemicals in metal-lined boxes buried in the lawn. The chemicals were visible through the glass tops, level with the ground. Water reached the chemical via underground piping from a catchment area at a higher level, and eventually drained away to a lower level. Herring, in a catalogue statement, spoke of his wish to 'utilise the strong and wilful determinism of the elements', but the visual impact was not spectacular.

David Parsons showed two untitled works and an eight-foot by eight-foot fibreglass grid. The grid demonstrated his intentions most clearly; they were to enquire 'into the nature of space as a fundamental discipline . . . the way in which proportions, scale, ratio, and measurement may exist, in which space becomes a clearing house for each of these factors'. In fact, even the restricted space of the Camden Arts Centre garden triumphed over whatever it was that Parsons was attempting to do to it. Two hits out of four shots does not seem at all a bad score in an exhibition of this sort.

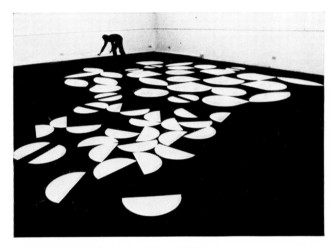

Timothy Drever Moonfield 1969
Painted hardboard

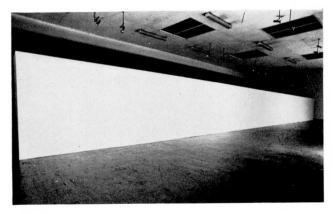

Peter Joseph Yellow Wall 1969
Painted canvas

154

Richard Smith

Kasmin Gallery *November*

Richard Smith is certainly one of the leading figures of his particular generation in English art. This exhibition consisted of only four large pictures, in Smith's now familiar mode which lies somewhere in between painting and sculpture. The canvas was stretched over a three-dimensional framework, and was shaped and folded in such a way that the spectator accepted it both as a surface to be painted on, and as a sculpture.

The largest and most successful of the four pictures was one called *Riverfall*, which occupied the main wall of the gallery. Nigel Gosling spoke of it in the *Observer* as, 'a great weir of green'. He went on: 'luminous streaks of colour slide downwards and outwards over a curved canvas to end in a clean-cut edge which has the darkest of deep water and the finality of rock'. Few contemporary works of art really deserve the rapturous descriptions which critics think up for them. This certainly had a formal authority which reminded one of the very best Japanese screen paintings. The individual thing about this artist is that he has never entirely abandoned the painterly. *Riverfall*, and the other works in the show, owed their distinction at least in part to the fact that the colour was still treated in a romantic, painterly way. These were not works in which theoretical principle was everything, but were the highly personal expressions of a refined, and by now very experienced, sensibility. (*See colour illustration page 84*)

Richard Smith Rustle 1969
Oil and epoxy on canvas 72″ × 96″ × 2″

William Tucker : John Walker

Leeds City Art Gallery, Leeds

November - December

The two artists concerned are the current Gregory Fellows in Painting and Sculpture respectively at Leeds University. Though each is well known, and though each has several one-man shows in London to his credit, this was the first time that either had been seen on any scale in Leeds. Both Walker and Tucker showed a good range of work, covering several years of activity – a specially good thing in the case of Tucker, as his 1969 one-man exhibition at the Kasmin Gallery was something of a disappointment (see p. 111). It was, however, John Walker who stole the show with a range of large, and particularly ravishing paintings.

Clearly, exhibitions such as this are to be welcomed.

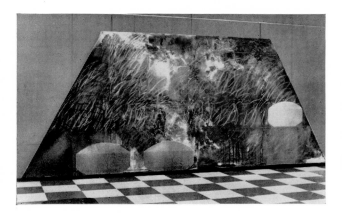

John Walker Large drawing August 1969
Chalk and acrylic on canvas 105″ × 264″

John Walker Hannah May 1969
Acrylic on canvas 96″ × 168″

'1969 Northern Young Contemporaries'

Whitworth Art Gallery, Manchester

November - December

This show had a number of artists in common with the John Moores competition entries which were simultaneously on view in Liverpool. The total atmosphere was, however, very different. It cannot be said that the students, from art colleges all over England, who had entered their work produced anything which looked like a breakthrough to a new style. Instead one had a parade of all the established modes, from a rather chilly late-Hockney realism to various types of Minimal art. What was on view, nevertheless, had an assurance and vitality which were missing from the majority of the Diploma shows which the London art colleges put on this year. The exhibition seemed to have been outstandingly well selected by its committee – Mark Glazebrook, Malcolm Hughes and John Walker. The difficulty about nearly everything on view was quite simply that though admittedly competent of its kind, it did not seem to lead anywhere. Few of these young artists would be able to develop from the work they were showing at the Whitworth. The only possible course open to them was a risky leap into quite another style.

As a demonstration of the liveliness of response to be found in the best British art colleges, it was, however, impressive.

Michael Porter (London: Chelsea) It's amazing what you can do with plastic rods nowadays even if they are made out of wood 1969
Wood, metal and emulsion 90″ × 50″ × 34″

'6 at the Hayward'

November - December

It is an excellent thing that the Hayward should be used as it has been recently to help young artists, as well as being the setting for prestige exhibitions. This group of six artists, brought together at short notice by Michael Compton of the Tate, ranged in age from twenty-five to thirty-five years. Some were fairly well known – the painter Ian Stephenson and the sculptor Victor Newsome, for instance – others have yet to make their mark. Unfortunately it is impossible to use the show as a means of predicting the direction which British artists will be taking next, because its most striking features were its unevenness of quality and its extreme diversity of style. The two most impressive contributions could not have been further apart

Hilary Fell (Manchester) Untitled 1969
Perspex, rope and resin 64″ × 108″ × 80″

stylistically. One was a vast black fibreglass structure by Michael Sandle, who has been hovering on the edge of making a major reputation for himself for some years. The piece is the embodiment of private fantasy; Mr Compton, in one of the less opaque sentences in his catalogue notes, said of him that 'his sculptures . . . although they do arise from a private obsession, are projected in as public a manner as baroque sculpture or Hollywood movies'.

Overblown and demanding, Sandle's monumental creation imposed itself on the spectator like a monologist buttonholing one at a party. Fortunately, unlike most monologues, this one was not a bore.

Barry Flanagan's contribution could not have been more different, consisting as it did of short lengths of rope scattered on the gallery floor, a pile of sacks in a corner and some rectangular patches of projected light. Where Sandle ignores the setting, Flanagan co-operates with it to produce the work of art. One might describe him as being more gardener than sculptor; the only comparisons one can conveniently think of for the work he showed at the Hayward are the famous sand gardens of Japan.

The other contributors were in varying degrees disappointing; although Keith Milow did some upsetting things with the square white room allotted to him. Two large yellow triangles of plastic sheeting, holding photographic images, shot out of one corner, hung on metal rods that sloped into the floor. Farther along, another blue-grey triangular shape came straight out from the wall at the spectator, and that also

vanished abruptly into the floor. Other images were imbedded in tinted resin, conventionally rectangular and conventionally hung. The resin had been treated with 'metal powder', causing a milky opaque effect which almost blotted out – as in a blizzard – the picture underneath. Milow's aim, according to a note on the artist by Mr Compton, is: 'to exchange and pervert the traditional roles of support, image, paint, varnish, etc. . . . giving an unexpected materiality to the conventional components of a picture . . . ' The effect was indeed environmental, but his contribution to the exhibition was spoilt by over-preciosity. However, he is an artist whose future work might repay close inspection.

It is clear that the opportunities which young artists clamour for, and which (despite the criticisms of organisations such as F.A.C.O.P.) the Arts Council provides on an increasing scale, can vanquish those to whom they are given. One result of encouraging younger artists can undoubtedly be to show up their immaturity.

Barry Flanagan Untitled 1969
Sacks and light

Michael Sandle Monumentum pro Gesualdo 1966–9
Fibreglass 144″ × 259″ × 105″

'Play Orbit'

Institute of Contemporary Arts

*December**

The Institute of Contemporary Arts has already staged a number of highly successful theme exhibitions, among them the Computer Art show entitled 'Cybernetic Serendipity' in 1968, which was devised by the same organiser who created 'Play Orbit' – Mrs Jasia Reichardt.

Mrs Reichardt has always managed to find not only interesting objects but interesting ideas for the shows she puts on, and 'Play Orbit' was no exception. By asking artists to create something which was their idea of a plaything (not necessarily for a child) she at the same time managed to raise the question of the purpose of the work of art in modern society – one answer being, of course, that it can be no more than a toy. The exhibition was lively, ingenious, well arranged and thoroughly pleasurable. The invitation to participate was an unlimited one – anyone who wanted to exhibit was allowed to do so. Well-known artists exhibited by the side of unknowns. The results were much less uneven than might have been predicted. The practical problem of designing something which could really be played with seemed to focus artistic energies very successfully.

Some of the best exhibits, however, were the so-called art college projects – *travaux d'équipe* by the students of a number of leading art colleges. Perhaps the most beautiful of these was the sphere-puzzle, devised by students at the Hornsey College of Art. A clear plexiglass globe, full of transparent tubes, this was a maze through which the player had to feed a little red ball until it dropped through a division into the other half of the object. Whereupon one reversed the sphere and began again. This, like so many other contributions to the show, made the point that it is difficult to invent an entirely new plaything – such puzzles, though on a smaller scale, have long been familiar to children. The only truly new playthings were objects, such as Victor Newsome's *Chop* – a pair of hatchets with which the two players were invited to slice one another to pieces. New this may have been, but one didn't envisage a great future for it either in nurseries or in drawing-rooms. All the same it seemed a pity that there were not more

dialectical objects of this nature in the exhibition. A bulky catalogue contained extremely interesting statements made by the artists about what a toy is or should be – for example, Diane Ismay's remark that the 'prerequisite of the perfect toy is that it should wear out easily all over, and disappear at the moment when it is no longer needed'.

The toys, however, though charming, were often less adventurous than the statements connected with them implied. All the same, this was one of the best and most original exhibitions of the year under review – the kind of thing which one wished the I.C.A. would do more often.

*A smaller version of this show was seen at the Welsh National Eisteddfod at Flint in August.

Lise Bayer Mr. Snake 1969
PVC coated fabric with foam plastic filling
144″ long × 12″ diameter
Photograph: Don Flowerdew

Alexander Weatherson Polymorphs 1969
Wood and coloured resins (11 to a box) 12″ × 14″ × 3″

Liliane Lijn Water Column 1969
Transparent cylinder with fluorescent horizontal discs
allowing water to seep through, which can be turned
upside down like an hour-glass, shaken or rolled.
15″ high × 3″ diameter
Photograph: Don Flowerdew

Tom Hudson Executive noughts and crosses 1969
Noughts in perspex, crosses in steel on a purple PVC mat
12″ × 12″ × ¾″
Photograph: Julian Shepherd

John Moores Liverpool Exhibition

Walker Art Gallery, Liverpool

November - January

This was the seventh in the bi-annual series of John Moores exhibitions, all of which have been held at the Walker Art Gallery, Liverpool. During the period of its existence, the John Moores shows have been the most important art events to be held regularly outside London. They have charted the development of British painting, from the days of kitchen-sink realism (Jack Smith was the first Open prizewinner in 1957, and John Bratby won the junior prize), through the British variant of Abstract Expressionism and the establishment of Pop art. At the same time, the various juries have been successful in finding and exhibiting then unknown, but talented, painters – a notable case was John Walker, who was awarded third prize in 1965. As with all large art competitions there has been a tendency to give the major awards to painters sufficiently established not to be in need of them, but this has gone hand in hand with a surprising sensitivity to the mood of the moment in British art. This year the show made a less happy impression. The two main prizewinners – Richard Hamilton and the late Mary Martin – were

prestigious names. Both should arguably have been honoured years ago, but this year the jury made choices so safe as to be boring. Among the works selected for exhibition were paintings by a large number of very well established British artists. They included: Allen Jones, Kenneth Martin, Henry Inlander, Patrick Caulfield, Patrick Heron, Peter Blake, Jack Smith, Victor Pasmore, Tess Jaray, John Hoyland and Henry Mundy. Many of these, in fact, were prizewinners on previous occasions. Yet the total impression made by the exhibition was one of stagnation. The established artists were doing very much the same things that one was accustomed to see them doing, though often rather less well. Few seemed to have developed significantly since they first made

Mary Martin Cross
Stainless steel and wood 54″ × 54″

Tom Phillips Thesis as Object: with Scholarly
Apparatus
Acrylic 98¾″ × 57″

their appearance in the John Moores. The five minor prizewinners, all of whom were relative unknowns, were in their way interesting, the complex work by Tom Phillips especially so, but there was nothing which had the impact of a revelation.

The one consistent tendency detectable among the works selected for hanging was an impatience with the competition rules. The John Moores concerns itself with paintings, or at least with objects which hang on a wall and 'do not project more than six inches' from it. Many of these works, with their attachments and dangling bits and pieces, were less obviously painting than sculpture – none more so than Mary Martin's prizewinning metal relief. Since the whole tendency in

Britain, as elsewhere, is away from the rigid categorisation of works of art, competitors could hardly be blamed for stretching the regulations as much as they could. The comparative absence of works which could properly be defined as paintings did, nevertheless, raise the question of whether competitions such as the John Moores were still relevant to the present art situation, or whether this well-intentioned institution has for the time being served its purpose.

Yet perhaps there was another factor which contributed to the dullness of the show: the fact that the jury were all artists. In previous juries there has always been an admixture of critics and theoreticians, and their choices (one suspects) had a certain healthy eccentricity.

Robert Owen Four × Four
Aluminium and perspex
(average size of each: $20\frac{3}{4}'' \times 10\frac{3}{4}''$)

Five Studio Showings

December

These five showings were arranged by the authors of this volume on Sunday, 7th December as a pilot-scheme. Our hope is that the idea may be taken up, either by art-impresarios, or by co-operatives of artists. Guests were asked to assemble at a central point, and a coach then took them from studio to studio. None of the five young artists who participated has a regular arrangement with a London commercial gallery, though all have shown successfully in mixed exhibitions from time to time. Their plight is therefore typical of many other young British artists. In addition to this, there is the fact that much of their work tends to be strongly environmental. Lawrence Preece and Adrian Phipps Hunt created environments especially for the occasion, while it was almost impossible to see how a commercial gallery without a very large space at its disposal could have shown Nigel Hall's suspended sculptures. The fact that Adrian Phipps Hunt showed at 45 Tabernacle Street, London EC 2 enabled the visitors to see something of a studio-conversion which the Arts Council has supported. The participating artists were in all cases chosen because the organisers felt in sympathy with their work, but between them they gave at least some idea of the range of possibilities which British artists now find in abstract and experimental ideas.

The artists who took part were:

George Percy. Born 1935. Studied at St Albans School of Art, 1955–8, and the Academy of Fine Arts, Munich, 1958–9. Showings in mixed exhibitions include: London Group; Arts Council of Northern Ireland Open Exhibition; Northern Young Artists; Edinburgh Open 100.

Lawrence Preece. Born 1942. Studied ceramics at Brighton College of Art, 1958–63; taught full-time in the East End, 1963–8; Visiting Lecturer in 3-dimensional design at Brighton, 1968–9, and at present Visiting Lecturer, Hornsey College of Art. Showings: participated in a two-man exhibition at the New Chelsea Gallery, 1962; represented in the City Festival Exhibition, 1968; one-man exhibition at the Greenwich Theatre Gallery, 1969.

Nigel Hall. Born 1943. Studied at the West of England College of Art, Bristol, 1960–4; and at the Royal College of Art, London, 1964–7; travelled through the U.S.A., Canada and Mexico on a Harkness Fellowship, 1967–9. Mixed exhibitions include: *Salon de Mai*, Musée d'Art Moderne de la Ville de Paris, 1967; 'New British Painting and Sculpture', Los Angeles County Museum, California, 1968. One-man exhibitions: Galerie Claude Givaudan, Paris, 1967; Nicholas Wilder Gallery, Los Angeles, 1968.

Adrian Phipps Hunt. Born 1940. Studied under A. J. J. Ayres at Brighton until 1961; worked as village postman, Pevensey, Sussex, 1961–4. Showings: first exhibition of large works done in plaster, Lewes, 1964; showed architectural layouts at Manchester and Bradford, 1965; included in Camden Arts Centre exhibition, 'Survey 68', 1968.

John Loker. Born 1938. Studied Bradford College of Art, Graphic Department, 1954–8; and at the Royal College of Art, London, 1960–3. Awarded Abbey Minor Travelling Scholarship, 1963. Mixed exhibitions include: London Group; Young Contemporaries; Post Biennale, R.C.A. Galleries; 'British Painting', Lyon; Edinburgh Open 100; 'Preview London', Camden Arts Centre.

Lawrence Preece – studio view

George Percy – studio view

John Loker – studio view

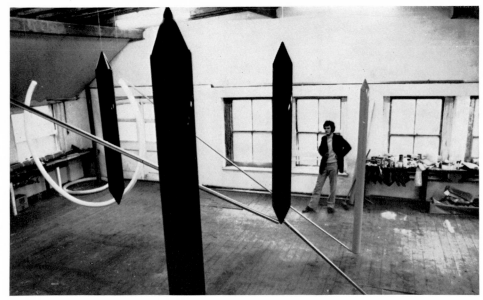

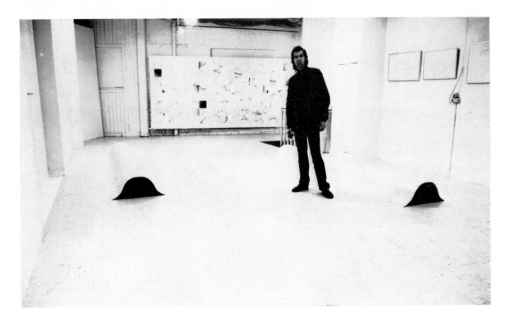

Adrian Phipps Hunt – '4 into 3' – material 9-inch square
Dunlop Selflay Tiles. Environment constructed in a room
35 feet × 17 feet 9 inches, with bumps 9 inches high by
12 feet long, fabricated in resin reinforced with glass
fibre. Tiles were fitted wall to wall, so as to 'belong'. The
work was based on a scale of a man at 6 feet.